Mateusz Urbanowicz 手繪作品集
The Artworks of Mateusz Urbanowicz

東京老鋪
Tokyo Storefronts

Mateusz Urbanowicz 著
マテウシュ・ウルバノヴィチ

Sideranch Inc. 編
サイドランチ

韓書妍 譯

前言

Introduction

東京的小店很有味道。

我初次造訪東京是一趟小旅行，當時我們住在遠離市中心的高島平，因為住宿費用低廉。我們抵達時夜色已深，因此我第一次真正看見日本，是在隔天早上散步穿過郊區，前往荒川的時候。

每次和日本人提起這段經歷，他們總是驚訝不已——他們說：那一帶沒有任何有趣的東西啊。但是對我來說，這些地方有如靈感大爆發。

過去所有我曾在日本動漫中看過的景色，一口氣在我眼前鋪展開來。我感覺自己彷彿回到熟悉但遺忘已久的地方，而不是全新的陌生之地。這種奇異的懷舊感，就好像我知道轉角處有什麼，但是當真正走到了那裡，一切都比我想像的更有趣。當時我就知道，我要留在日本，畫下我看見的一切景色。

2016年三月，我動筆畫了一系列店鋪的插圖，作為私人的小小藝術計畫。當時我在東京的動畫工作室擔任全職的背景畫家。而現在在你手中拿著的這本書，則是這個小小計畫的延伸。

這本書中選擇的店鋪，和我最初的私人計畫中的十家店鋪，都是以相同方式選出——先拍攝一系列照片，仔細觀察後，畫下最喜歡的店家。

我希望尚未造訪東京的你們，以及已經熟悉這座城市的你們，都能在本書中的店鋪裡感受到有趣與奇異的懷舊風情。

The small Tokyo shops have "something" in them.

When I first came to Tokyo, just for a trip, we stayed in Takashimadaira - far from the popular city centre - just because it was cheap. We arrived late at night, so my first opportunity to really see Japan was during our morning walk the next day through the suburb to see the Arakawa river.

When I talk about my experiences at this time to Japanese people, they are astonished - there's nothing interesting around there, they say. But for me, these places were an explosion of inspiration.

All the sights I had seen in Japanese animation and comics sprawled before my eyes. I felt more like I was coming back to a place I knew but forgot rather than somewhere completely new. I had this strange, nostalgic feeling, like I knew what was around the corner yet when I actually went there everything was more interesting than I could imagine. It was then that I knew I would like to stay in Japan to illustrate all the sights I saw.

I started to paint the first series of illustrations portraying shops in March 2016 as a small private art project. At the time, I was working full time as a background painter in a Tokyo animation studio. This book you are holding right now is the continuation of that small project.

I chose the shops for this book the same way I chose the first 10 buildings for my private project - I looked over the many pictures I had taken during my walks and just painted the ones I liked.

I hope that both those of you who have never been to Tokyo and those who know the city well will find the shops in this book interesting and weirdly nostalgic.

東京・日本橋街角 / Mateusz 和妻子香苗
At the street corner of Nihombashi, Tokyo / Matt and Kana, his wife

目次

Contents

前言　Introduction .. 002
地圖　MAP .. 006

第1章　千駄木 ― 神保町地區 • 008
Chapter1 Sendagi — Jimbocho Area

01　小野陶苑　Ono-tōen .. 010
02　山根肉店（已拆除）　Yamane Meat Shop（Demolished）........... 012
03　壽司乃池　Sushi Noike 014
04　伊勢辰谷中本店　Isetatsu Yanaka Honten 016
05　菊見煎餅總本店　Kikumi Rice Crackers Shop 018
06　榊原商店（歇業/私人住宅）　Sakakibara Store（Closed/Private-house）... 020
07　鶴谷洋服店　Tsuruya Tailors 022
08　鉢卷天婦羅　Tempura Hachimaki 024
09　誠心堂書店　Seishin-do Bookstore 026
　　―內部展開圖　Inside View

店鋪資訊01　Shop Notes 01 030

第2章　秋葉原 ― 日本橋地區 • 032
Chapter2 Akihabara — Nihombashi Area

10　北海麵包店　Hokkai Bakery 034
11　日米無線電機商會　Japan-US Transceiver Company（Radio Garden）... 036
12　岡昌襯裡鈕扣店　Okasyou Linings&Buttons Shop 038
13　海老原商店（歇業/私人住宅）　Ebihara Shōten（Closed/Private-house）... 040
14　榮屋牛奶堂　Sakae-ya Milkhall 042
15　江戶屋　Edo-ya ... 044
16　中央物流株式會社　Chuo-butsuryu Inc. 046
17　生毛屋　UBUKEYA .. 048
18　壽堂　Kotobuki-do ... 050
19　大勝軒　Taishō-ken .. 052

店鋪資訊02　Shop Notes 02 054

第3章　淺草 ― 北千住地區 • 056
Chapter3 Asakusa — Kita-senju Area

20　岡添耳鼻咽喉科眼科醫院　Okazoe Otolaryngology&Ophthalmology ... 058
21　小泉坐墊屋（已拆除）　Zabuton Koizumi（Demolished）.......... 060
22　菊屋橋照相館　KIKUYABASHI Camera Corner 062
23　金桝屋氣球專賣店（已拆除）　Kanemasu-ya Rubber Store（Demolished）... 064
24　植村屋　Uemura-ya ... 066
25　佃屋酒店　Tsukuda-ya Liquor Shop 068
26　天安　Tenyasu ... 070
27　矢島照相館（歇業/私人住宅）　Yajima Photo House（Closed/Private-house）... 072
28　道產子千住一丁目店　Dosanko Senju-1chome 074
　　―內部展開圖　Inside View

29 鮒秋　Funaaki ································· 078

30 菊屋機車行　Kiku-ya Motors ··················· 080

31 小島藥局　Kojima Pharmacy ··················· 082

店鋪資訊 03　Shop Notes 03 ····················· 084

第 4 章　赤羽 ─ 品川地區 • 086
Chapter4 Akabane — Shinagawa Area

32 丸全社　Maruzen-sya ························· 088

33 寶美樓　Hōbiro ····························· 090

34 成文堂早稻田正門店　Seibun-do Front gate of Waseda Univ. · 092

35 中島屋酒店　Nakashima-ya Liquor Shop ········· 094

36 小林理容室（已拆除）　Kobayashi Barber Shop（Demolished）· 096

37 精肉大田屋（已拆除）　Ōtaya Butcher Shop（Demolished）· 098

38 多姆咖啡　café DOM ························· 100

39 長屋咖啡　TENEMENT ························ 102

40 費洛斯　FELLOWS ··························· 104

41 丸屋鞋店　Maru-ya Footwear Store ············· 106

店鋪資訊 04　Shop Notes 04 ····················· 108

第 5 章　中央線沿線地區 • 110
Chapter5 Around the Chuo Line Area

42 齊藤　Saitou ······························· 112

43 鳥久　Torikyu ····························· 114

44 肉醬屋　Miito-ya ··························· 116

45 酒藏千鳥　Sakagura Chidori ·················· 118
　　─內部展開圖　Inside View

46 卜派　Popeye ····························· 122

47 庫庫廚房　Kitchen KUKU ···················· 124

48 石村輪業＋神樂坂自行車　Ishimura Cycle＋Kagurazaka Cycle · 126

49 不倒翁堂（歇業／私人住宅）　Daruma-do（Closed/Private-house）· 128

50 陽光理容室　Sunny Barber Shop ··············· 130

店鋪資訊 05　Shop Notes 05 ····················· 132

第 6 章　Mateusz 的工作室 • 134
Chapter6 Mateusz's atelier

工作室　Room ······························· 136

工具　Tools ································· 140

作畫方式　How To ···························· 148

後記　Afterword ····························· 156

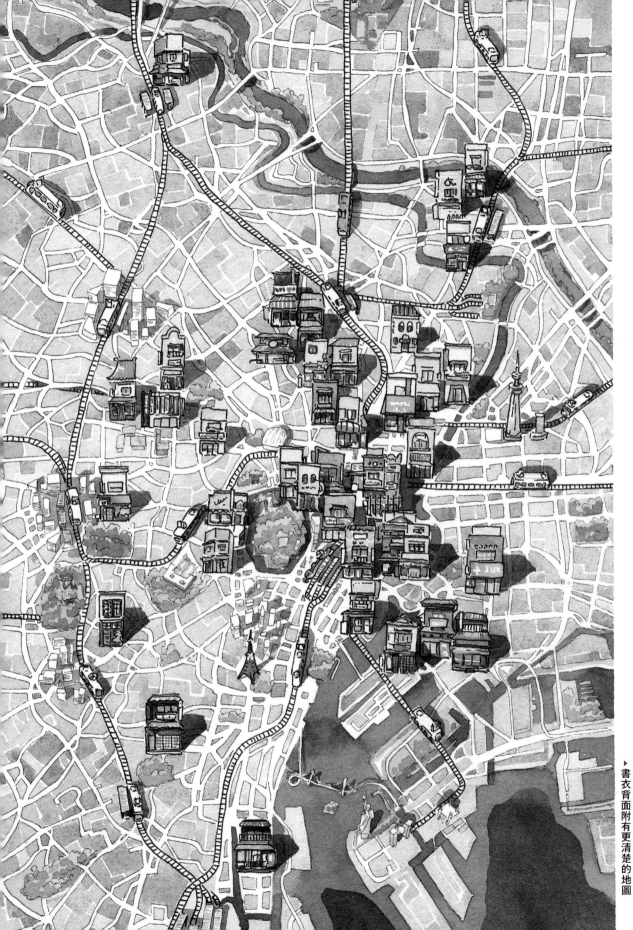

▶書衣背面附有更清楚的地圖

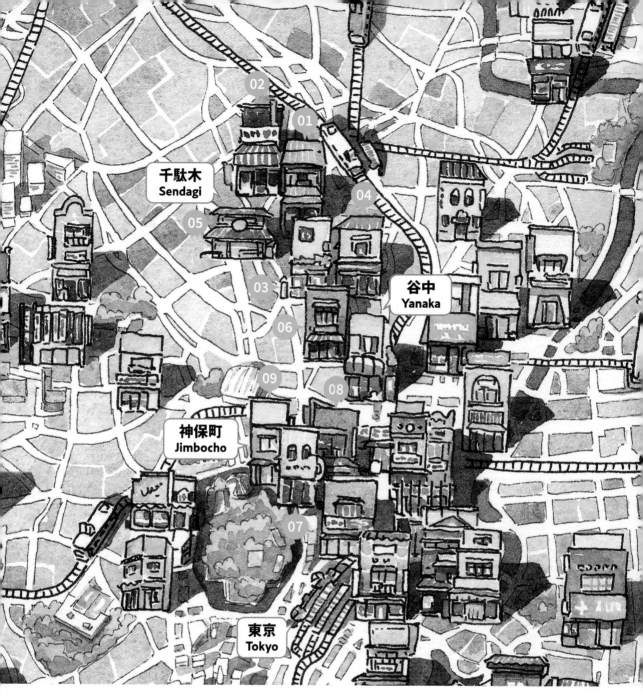

千駄木
Sendagi

谷中
Yanaka

神保町
Jimbocho

東京
Tokyo

01　小野陶苑　Ono-tōen ··· 010
02　山根肉店（已拆除）　Yamane Meat Shop（Demolished） ··········· 012
03　壽司乃池　Sushi Noike ··· 014
04　伊勢辰谷中本店　Isetatsu Yanaka Honten ···························· 016
05　菊見煎餅總本店　Kikumi Rice Crackers Shop ························· 018
06　榊原商店（歇業/私人住宅）　Sakakibara Store（Closed/Private-house） ··········· 020
07　鶴谷洋服店　Tsuruya Tailors ·· 022
08　鉢卷天婦羅　Tempura Hachimaki ·· 024
09　誠心堂書店　Seishin-do Bookstore ······································ 026
　　一內部展開圖　Inside View

店鋪資訊01　Shop Notes 01 ··· 030

第1章
Chapter1

神保町 Jimbocho 地區 Area

千駄木 Sendagi

千駄木 Sendagi 小野陶苑

小野陶苑
Ono-tōen

小野陶苑是位在谷中商店街的陶製品商店，牆面是以紅磚砌成，木製招牌上寫著店名。目前店鋪正面以一幅黑白圖畫裝飾，由於並不是建築本身的元素，因此我並沒有在畫中加入這一部分。

Ono-tōen is a pottery shop in the Yanaka shopping district with red tiled facade and a wooden sign bearing the shop's name. Currently, there is a black-and-white picture on the front of the shop, but since it is not an element of the original building, I did not draw it this time.

小巧的玻璃鈴稱作「風鈴」，當下方繫著的小紙片隨風吹動，就會發出美麗聲響。在日本，夏季時會將風鈴掛在窗外或玄關處做為裝飾。

Small glass bells that make a beautiful sound when the wind moves them called *furin*, or windchimes. These are displayed outside windows and the entrances of homes during summer in Japan.

某些地區為保障日照權，土地使用規範禁止建造垂直高樓。而像這樣將屋頂設計成特定斜度，就能讓陽光照進街道。

In some places, zoning regulations forbid building high, straight vertical buildings to protect the right to sunshine. Setting the roof back at an angle lets the sun shine on the streets.

這些是陶製蚊香容器。造型像小豬的稱為「蚊取り豚」，意思就是「除蚊豬」。這些販售的蚊香豬有各種可愛造型。

Ceramic containers for mosquito coils. The ones that are shaped like a pig are called *ka-tori-buta*, which means literally "mosquito-killing-pig". The ones on sale here had many different cute shapes.

店家的園藝用品區。盆栽需要的所有物品都在這裡，包括植土、花盆、支架、澆水器以及其他工具，備貨相當齊全。

A gardening area at the side of the store. Everything you need for your houseplants, including soil, pots, support, watering cans and more, is here.

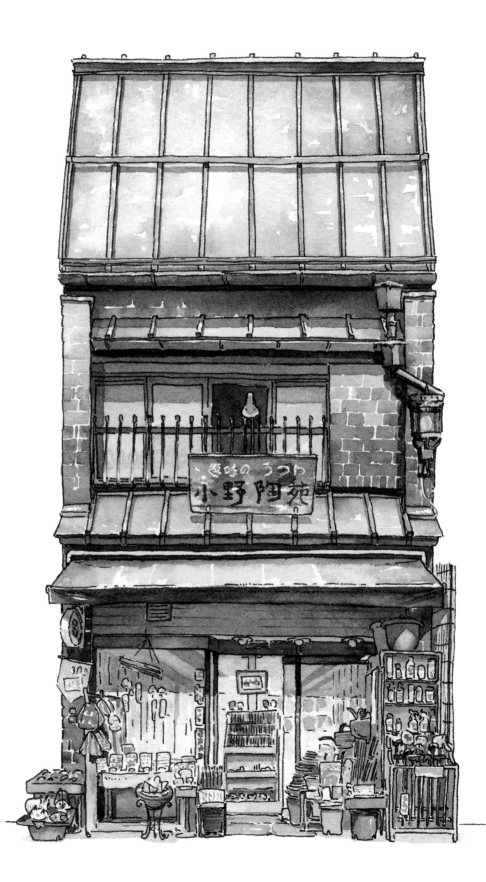

02 （千駄木 Sendagi）山根肉店

ヤマネ肉店 (已拆除)
Yamane Meat Shop (Demolished)

本店是一家肉鋪，門口有顯眼的紅白相間遮雨棚。這是最初的十張店鋪系列插畫中極受歡迎的一張，但是很可惜已經結束營業了。肉鋪創立於1930年，深具歷史意義，可樂餅是招牌商品，深受當地居民與觀光客喜愛。

Yamane Meat Shop is a butcher shop with a distinctive red and white tent marquee. This was one of the most popular illustrations of the original ten in the shop series, but unfortunately the shop has since closed. Established in 1930, this historic shop's specialty was its croquettes, popular among locals and visitors alike.

這個金屬管線（或是排煙管）從令人意想不到的地方伸出，使整體店面更加突出，令人印象深刻，我很喜歡。

This metal duct (or chimney) comes out from the least expected place. I like how this makes the shop stand out, making it even more iconic.

紅白相間的遮雨棚和這家可愛的肉鋪是絕配，而且也讓底下的空間籠罩在漂亮的紅色影子中。我試著畫出金屬門框上的紅色反光。

This white and red marquee is perfect for this cute meat shop and also casts a nice, reddish shadow on the things underneath. I tried to paint how the color reflects on the metal frame of the doors.

肉餡可樂餅的廣告旗幟，原本是商店街廣受歡迎的商品。我聽說這裡的可樂餅特別美味。只可惜我還來不及嚐到店家就歇業了。

A sign advertising meat croquettes, which were popular along this shopping street. I was told that the croquettes here were especially delicious. It's a shame I did not get to try them before this shop closed for good.

招牌的設計非常大膽，只有「肉」字是紅色的，畫起來很有趣！

The bold sign with only the character for "meat" written in red was really fun to paint!

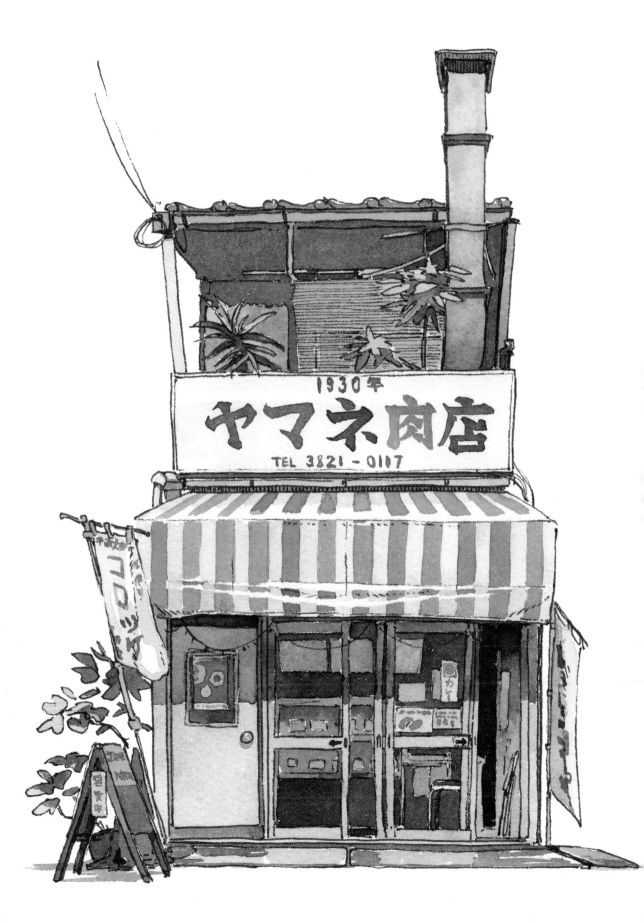

千駄木　Sendagi　壽司乃池

03 すし乃池 Sushi Noike

在這家千駄木車站旁邊的壽司店，可以品嚐到東京傳統的「江戶前」壽司。這棟建築的獨特之處，在於現代感的上半部混合傳統設計元素的下半部。外牆的白色線條把上半部劃分成方塊，相當有意思，為店家增添更多個性感。

Sushi Noike is a sushi shop right by Sendagi Station. Here, you can eat Tokyo's original style of sushi, known as *Edomae*. What is unique about this building is the blend of modern architecture on the top section and traditional design elements on the bottom. There are also interesting white lines dividing the top part adding more character to the look of the shop.

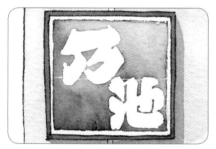

深藍底色搭配白色文字的巨大招牌非常醒目。作畫時使用留白膠也是一種享受。

The huge sign with white letters on a navy background really stands out. It was also fun to paint using the masking fluid.

上半部是偏現代感的方正設計，與下半部以木頭為建材的入口，以及其他傳統日本形式的設計細節形成強烈對比。

The top part has rather modern and square design. This contrasts well with the wooden entrance and other traditionally Japanese design details.

壯觀的紫藤長滿整個入口，也就是說，這家店的外觀會隨季節而變化。每到枝繁葉茂的時節，紫藤便會在玄關外形成獨樹一幟的影子。

This splendid wisteria growing all over the entrance means that the appearance of this shop changes greatly with the passing seasons. It also casts a unique shadow.

正面櫥窗中展示著小巧的指偶——正在做壽司的師傅和享用壽司的客人，以及一些鄰近地區的地圖。

In the display window there are small finger puppets of the sushi-master making sushi and a customer as well as some interesting area maps.

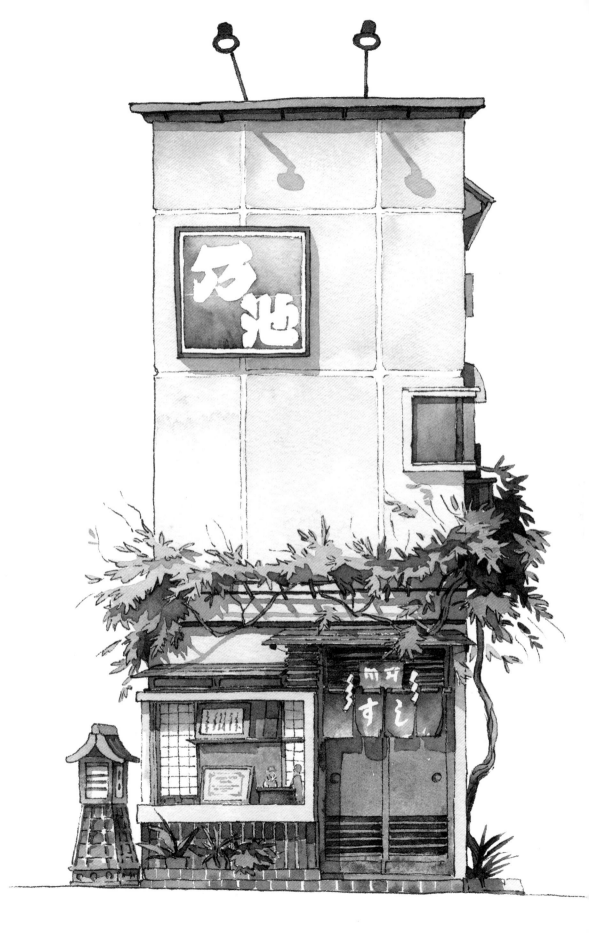

千駄木 Sendagi 　伊勢辰谷中本店

04 いせ辰谷中本店
Isetatsu Yanaka Honten

本店於1864 開業，專賣千代紙。「千代紙」是一種利用木版技術、手工印製的紙張，印有傳統日本圖紋。第一眼看見裝飾在店家上半部、色彩繽紛的巨大插畫招牌時，當下我就知道我一定要畫下這家店。

In business since 1864, Isetatsu is a shop that carries *chiyogami*. *Chiyogami* is a type of paper hand-printed with traditional Japanese patterns using woodblock printing technique. When I saw this shop's sign with its huge, colorful print, I knew straight away that I had to paint it.

這一部分對於店家的整體外觀而言非常重要，因此我盡可能重現其效果，不使用線條（也沒有線稿），並且限制用色，以表現出傳統日本木版印刷的特色。

This part is very important to the overall look of the shop, so I tried to recreate it as best I could using no lines (and no sketch) and a limited color palette to match the look of traditional Japanese woodblock prints.

建築物上設置了與街道垂直的招牌。我很喜歡這個招牌以及主要招牌上的小屋頂。屋頂的形狀使用日文漢字的「入」，帶有吸引顧客進入店內的意義。

A sign standing perpendicular to the street where the building is. I like this sign and the small roof over the main sign. The roof uses the shape of a Japanese "Enter" letter「入」, inviting customers in.

櫥窗中除了超大的紙漿製「犬張子」，旁邊也擺滿各種可愛的日本傳統玩具和人偶。繪製這些細節真是愉快。

There were many cute, traditional Japanese toys and figures on display along with a huge papier-mâché dog. I just had to try to paint them.

門口懸掛的「暖簾」上有店家商號，還有大大的「上」字寫在圓圈裡。這也是本店的店徽，唸做「丸上」。

The *noren* curtain at the storefront has the name of the store and the character for "up" written big in a circle. This is the crest of the shop and is read "Marujo", meaning "circle" and "up".

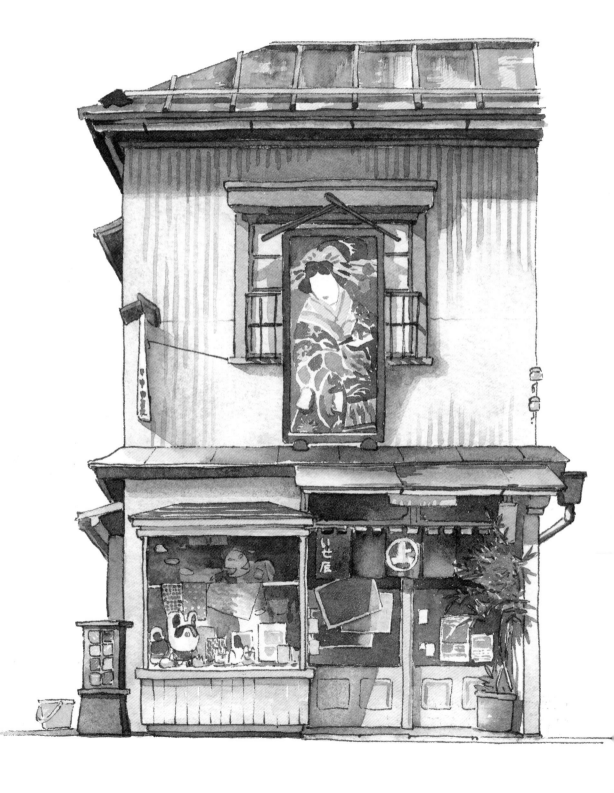

千駄木 Sendagi　菊見煎餅總本店

05 菊見せんべい総本店
Kikumi Rice Crackers Shop

這是一家仙貝專賣店。我覺得日式老宅的雨溝槽非常有趣,而且在這家店上看起來很漂亮!不僅如此,金屬材質的雨溝槽與屋頂上的瓦片交織出的畫面也極富想像力。房子屋簷上裝飾的家徽稱作「家紋瓦」。

This is a shop selling rice crackers. I find the rain gutters of old Japanese houses very interesting and they were splendid on this shop too! What's more, here were beautiful ceramic roof tiles with the family crest on them called *Kamon Gawara*.

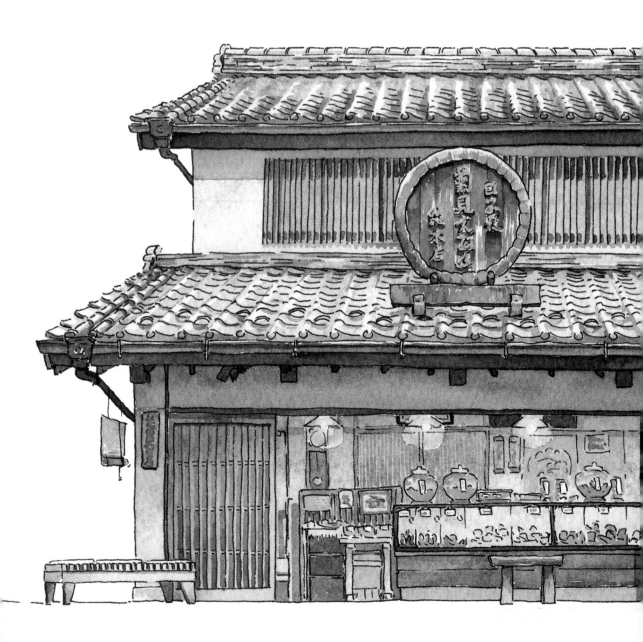

巨大的木製看板上有金色立體的店名。邊緣鑲上銅，使木板免受風雨吹打。現在木頭已經變成灰色，銅材也變成深綠色了。

A huge wooden sign with the shop's name in golden letters. Covered on all sides with copper to protect the wood from the rain, it is all gray and dark green now.

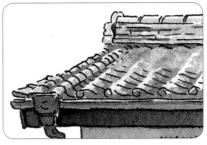

鋪著波浪形屋瓦（瓦屋頂）的房舍曾是東京的尋常景色，但是具有這麼氣派屋頂的建築現在已經越來越少見了。

Houses with roofs fully tiled with *kawara* were once a common sight in Tokyo, but recently it is hard to find them.

老式玻璃櫃中滿是美味的煎餅。這個玻璃櫃早在店面翻新前就已經在此服役。

An old glass showcase packed with tasty crackers. It has been used here since long before the shop was renovated.

這種圓滾滾的大玻璃罐叫做「地球瓶」，仙貝專賣店門口常可以見到。此處的玻璃罐裝滿小米果（あられ，糯米做成的米餅）。我喜歡光線映入玻璃罐映照出小米果的輪廓形狀，以及令其表面閃閃發亮的樣子。

This large round glass jar is called a *chikyubin* and is often seen at the front of cracker shops. Here, the jars were filled with *arare* (rice crackers made from glutinous rice). I like how the light shines through the outlines of the *arare* inside these glass jars.

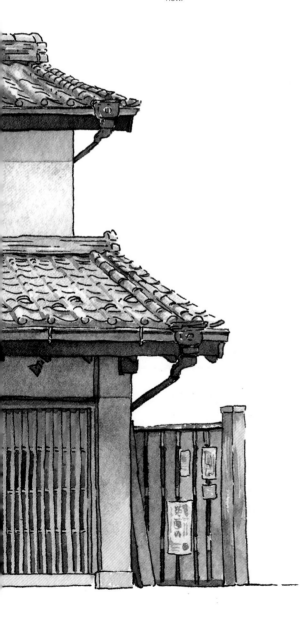

榊原商店 (歇業 / 私人住宅)
Sakakibara Store (Closed/Private-house)

這棟建築曾是掃帚專賣店，不過目前是私人建築。早在我開始繪製「東京老鋪」系列之前，在這一帶散步時就已經注意過好幾次這棟風采猶存的老房子。我一直很想畫這棟房子，藉由製作本書的機會終於動筆了！

This building used to be a broom shop. Currently it is used as a private residence. I saw this really handsome, old store few times while walking in the neighborhood well before starting the first series. I wanted to paint it very much, so I used this book as an opportunity to finally do it!

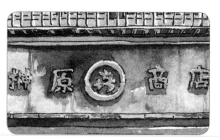

過去的老式店鋪常常在店面外牆鍍銅，增添外觀的豪華感。隨著歲月流逝，牆面的金屬氧化，變成偏藍的綠色，接觸到水的地方會變得幾乎全黑。然而這棟建築仍保有漂亮的銅綠。

Old stores often used copper cladding like this one on storefront to make the store appear lavish. Over time, the metal would oxidize to a bluish green color, then turn almost black in places where it came into contact with water. However, this building maintains its beautiful green color.

木雕金漆的字體組合成這家商店的招牌。可惜數年前第一個字就掉了，而且並沒有修補。我利用網路上找到的老照片當資料，重現招牌的樣子。

Wooden carved letters painted gold are making the sign of this shop. Unfortunately, the first letter fell off years ago and was never replaced. I recreated the sign using old photos found online for reference.

我描繪的冷氣主機是搜尋店家營業中的老照片時看到的，現在已經不一樣了。

The air conditioning unit looks different now, but I used one from an old photo I found while researching how the shop looked when it was still open for business.

小金魚在大大的陶盆裡優游自如，當然也少不了豐盈的水草！這些大盆從前似乎做為火盆之用，將燒紅的木炭放在厚厚的灰燼上疊起，用來加熱水壺裡的水。

The ceramic tank with small goldfish swimming in it can't be complete without some lush aquatic plants! Tanks like this were originally used as braziers. Burning charcoals were placed on a layer of packed ashes to warm up kettles full of water.

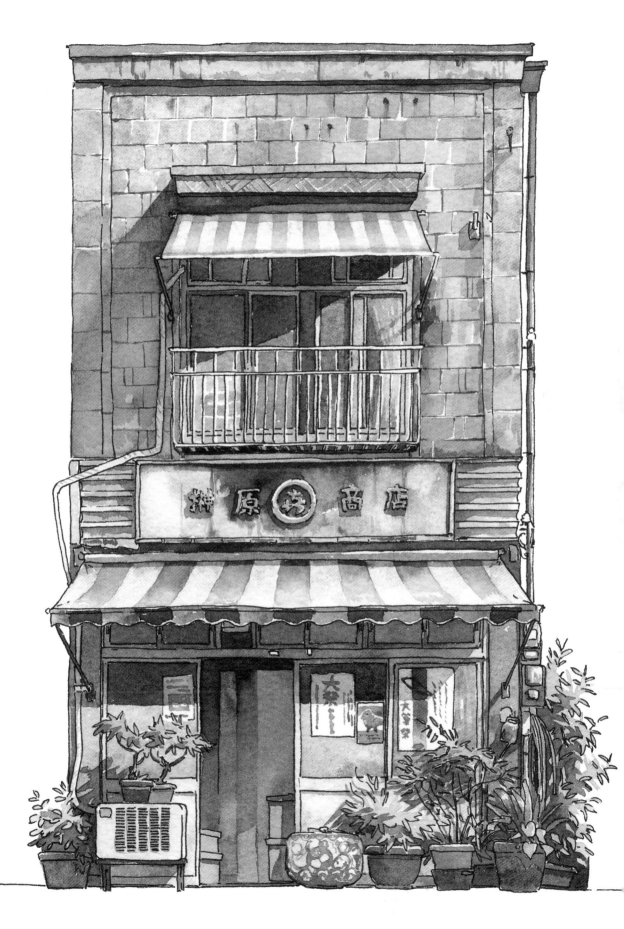

07 鶴谷洋服店
Tsuruya Tailors

神保町 Jimbocho 鶴谷洋服店

鶴谷洋服店最初是訂製西服店，現在則是雜貨店，販售各式懷舊物品。很可惜圓弧形的招牌不復存在，不過我在網路上搜尋這家店的老照片時看到此招牌，決定把它畫出來。

Originally an order-made tailor, this sundry shop now sells an assortment of retro items. While the round sign is sadly no longer there, I found it while looking for old photos of the shop online and decided to put it in the painting.

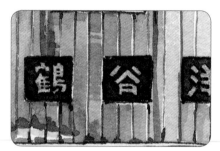

黑底搭配立體黃銅文字的招牌造型感十足。我決定把它畫成金色。目前招牌最前面加上了「元」一字，表示「前身」，不過因為這個字不屬於原始建築的一部分，我並沒有把它加入畫面。

This sign with three-dimensional letters on black background looked very stylish. I decided to use gold paint here too. Currently, a character meaning "former" has been added, but since it was not part of the original building, I did not include it in the illustration.

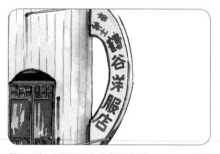

圓弧形招牌最初掛在店鋪的側面，如此一來從轉角也能看到。

This round sign was originally attached to the opposite side of the shop so it could be seen around the corner.

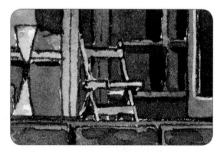

我很喜歡這張黃色的小椅子，彷彿某人恰巧有事暫時離開。因此決定把它畫出來。

I liked this small yellow chair. It looks like someone just left to go on an errand, so I decided to put it in the painting.

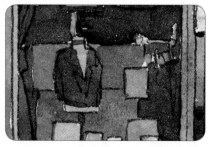

我想像店鋪仍是洋服店時的樣貌，並決定重現當時櫥窗的模樣。

I decided to recreate what I imagined the shop display would have looked like when it was still a tailor.

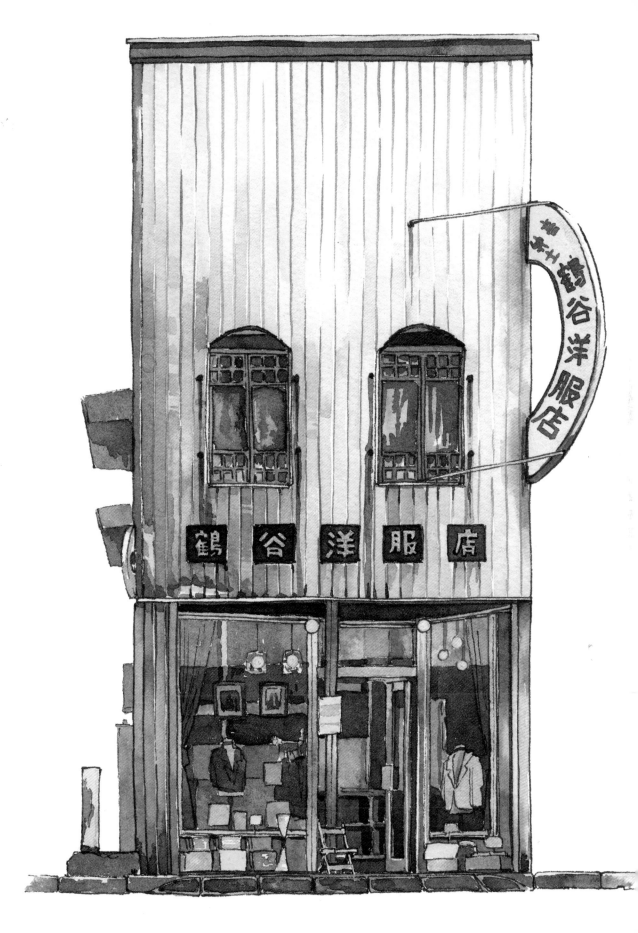

神保町 Jimbocho
鉢卷天婦羅

08 天麩羅はちまき
Tempura Hachimaki

這家出名的天婦羅專賣店成立於1931年。銀色的排煙管從二樓延伸到店鋪正面的屋頂。原因很可能是空間不足，因為這一帶的店家非常多，他們別無選擇，只能把排煙管放在建築正面。東京許多店家的排煙管都像這樣在店鋪正面。

This famous tempura shop was established in 1931. A silver duct extends from the second story to the roof in front of the shop. The reason for this is was probably lack of space: since there are so many stores in the area, their only choice was to put it on the front of the building. In Tokyo, there are many shops with ducts on the front like this.

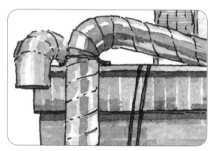

金屬排煙管連接自廚房的抽油煙機。排煙管通常是方形，不過這個是圓形的，而且看起來很新──因為金屬仍是閃亮亮的銀色。料理時產生的油煙會由此排出。

The metal duct from the kitchen fume extractor. These are usually boxy, but this one is round and probably quite new - the metal still shines silver. Smoke generated during cooking comes out through here.

中午用餐時間，店門口的小桌上擺滿整排便當，附近公司的上班族會來這裡買午餐。

At lunchtime, packed lunches line a small table at the storefront, where people working at nearby companies come to buy lunch.

牆上貼的小海報顯示知名作家江戶川亂步曾是常客！

Small poster showing that the famous author Edogawa Rampo was a regular here!

店門口裝飾的老照片透露其悠久歷史。照片上是店家創始人還有剛開業時與附近大學的學生。當時的店主很照顧這些棒球社的學生，每天免費提供他們天婦羅蓋飯呢。

Old pictures showing the long history of this store decorate the shop front. Shown in these photos is the original owner when the shop was established and students from the nearby university. The owner at the time supported these students, who were members of the baseball club, and would give them a free tempura rice bowl every day.

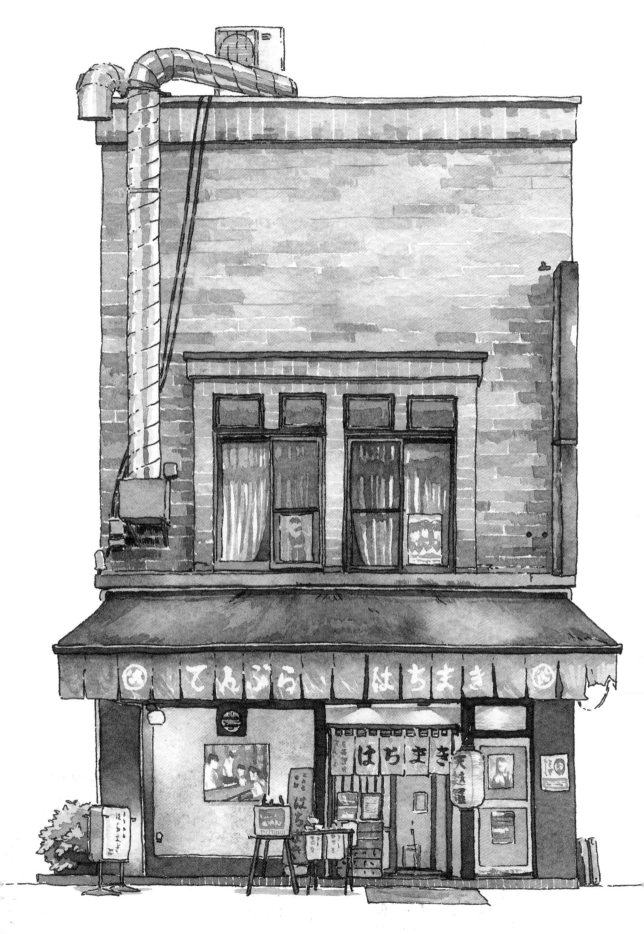

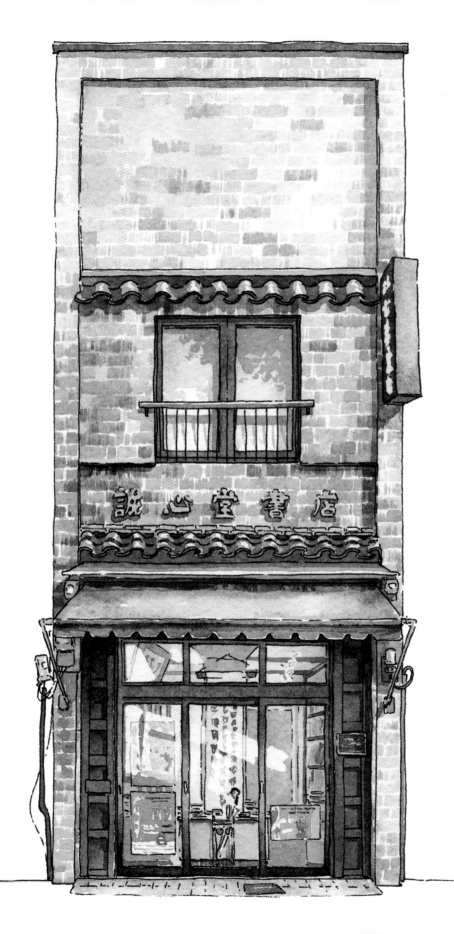

09 誠心堂書店
Seishin-do Bookstore

這間老書店座落在被稱為「書街」的神保町，專賣書法手抄本的「和本」（使用和紙和日本特殊裝幀法的古書）。店面外牆整面鋪滿瓦磚，建材質地饒富趣味，佈滿垂直紋路，不像大部分上釉的瓷磚會反光，而且摸起來手感相當粗糙。

Located in Jimbocho, sometimes called "Book Town" this old book store carries calligraphy and *wahon* (old books made from Japanese paper and bound using a method unique to Japan). The tiles covering the entire front of this shop had an interesting texture. Covered in vertical grooves, they did not reflect light like most glazed ceramic tiles and were quite rough to the touch.

小巧的雨遮以波浪形陶製屋瓦建造而成，巧妙地點綴店面。此處的瓦片是美麗的深藍色。

The small canopy roof made of ceramic tiles called *kawara* accents the front wonderfully. The tiles used here had a beautiful deep blue color.

這塊看板證明這家書店登記為重要的建築與文化歷史遺產。

A plaque certifying that this shop is registered as an important architectural and historical asset.

稱為「掛軸」的垂直捲軸上寫滿優美悠長的詩句。這些掛軸用來裝飾疊蓆間或茶室的「壁龕」（床の間，日式房屋的疊蓆間中墊高的木製空間）。

A long poem beautifully written on a vertical scroll called a *kakejiku*. These decorate *tokonoma* (a raised wooden area in the tatami room of a Japanese home) in tatami rooms or tea rooms.

這些堅固厚實的金屬框是後來加裝的，增加店面的耐震度。

These sturdy metal frames were a later addition to the shop to help it withstand earthquakes.

內部請見下一頁 ▶

◀ 外觀請見前頁

09 誠心堂書店 Seishin-Do Bookstore

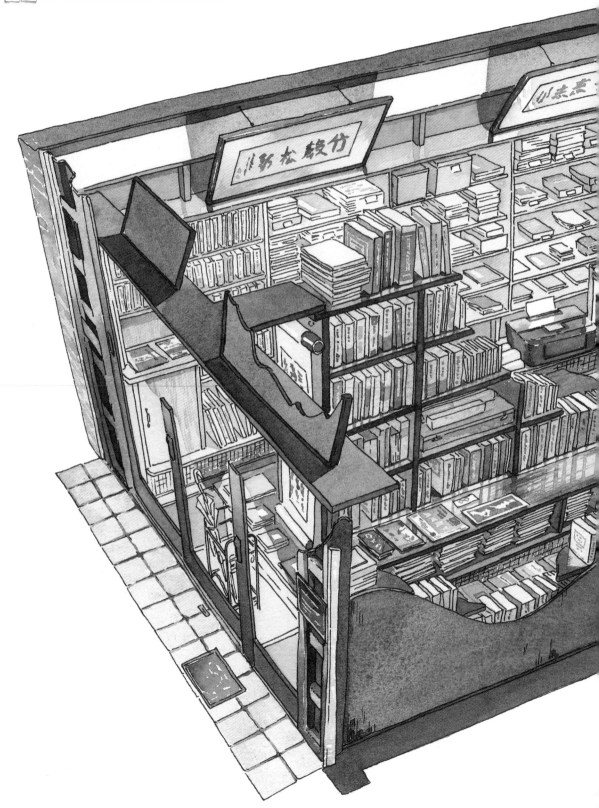

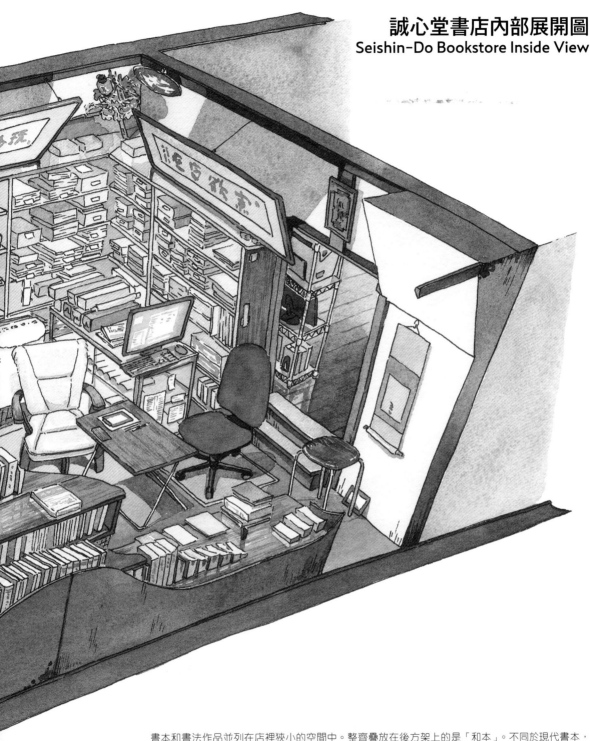

誠心堂書店內部展開圖
Seishin-Do Bookstore Inside View

書本和書法作品並列在店裡狹小的空間中。整齊疊放在後方架上的是「和本」。不同於現代書本，和本必須平放，否則會受到損傷。書架底部靠近地面的小磁磚是隱藏的裝飾（我不小心畫成藍綠色了，實際上這些磁磚是深褐色的）。

Books and texts line the narrow spaces inside this shop. Stacked neatly on the back shelves are the *wahon*. Unlike modern books, *wahon* must be laid on the side or else they will be damaged. The small tiles laid on the bottoms of the shelves near the floor are a hidden stylish point (incidentally, I have made them blue-green in the illustration, but in real life they were dark brown).

Shop Notes 01

店鋪資訊
01

01 小野陶苑 Ono-tōen

地址：台東区谷中3-8-12
落成年份：1974 年
附註：過去曾販售手工鋼筆。

Address: 3-8-12 Yanaka, Taito-ku
Year built: 1974
Note: Used to carry handmade fountain pens in the past.

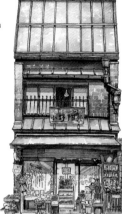

02 ヤマネ肉店（已拆除）
Yamane Meat Shop (Demolished)

地址：文京区千駄木3-43-9
落成年份：1936 年
附註：1930 年創立，店鋪目前改建中，暫停營業。

Address: 3-43-9 Sendagi, Bunkyo-ku
Year built: 1936
Note: Founded in 1930, the store is currently being rebuilt and has temporarily closed.

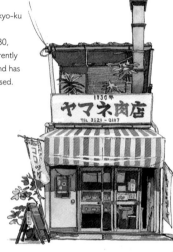

03 すし乃池 Sushi Noike

地址：台東区谷中3-2-3
落成年份：1945 ～ 60 年左右
附註：櫥窗中展示的指偶由店鋪後面的「指人形笑吉」製作。

Address: 3-2-3 Yanaka, Taito-ku
Year built: From about 1945 to 1960
Note: The finger puppets in the display window were made by Shokichi Finger Puppets behind the shop.

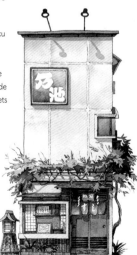

04 いせ辰谷中本店
Isetatsu Yanaka Honten

地址：台東区谷中2-18-9
落成年份：1970 年左右
附註：為了遠道而來的顧客，全年無休。

Address: 2-18-9 Yatanaka, Taito-ku
Year built: Around 1970
Note: Open all-year round for customers coming from far away.

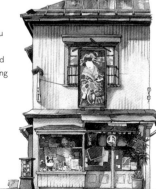

05 菊見せんべい総本店 Kikumi Rice Crackers Shop

地址：文京区千駄木3-37-16
落成年份：1977 年
附註：1875 年開業，這家老店最有名的米煎餅不是
　　　圓形的，而是正方形。

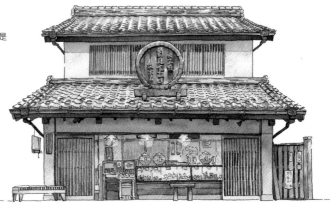

Address: 3-37-16 Sendagi, Bunkyo-ku
Year built: 1977
Note: First opened in 1875, this long-established
　　　shop's specialty rice cracker is not round, but
　　　square.

06 榊原商店（歇業 / 私人住宅）
Sakakibara Store (Closed/Private-house)

地址：祕密（因為是私人住宅）
落成年份：1920 年代
附註：過去還是掃帚專賣店時，
　　　三越之類的百貨公司會
　　　來這裡批貨。

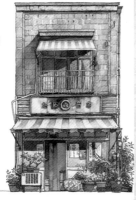

Address:
Secret (because it is a private
residence)
Year built: 1920s
Note: Apparently, when it was a
　　　broom shop, department
　　　stores such as Mitsukoshi
　　　would buy wholesale here.

07 鶴谷洋服店
Tsuruya Tailors

地址：千代田区神田神保町1-3
落成年份：1928 年
附註：目前是二手店，營業時間
　　　為週五、週六、週日及國
　　　定假日，下午兩點開店。

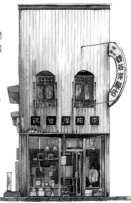

Address:
1-3 Kanda Jimbocho, Chiyoda-ku
Year built: 1928
Note: Currently a used goods
　　　store, this shop opens at
　　　2 PM on Friday, Saturday,
　　　Sunday, and national
　　　holidays.

08 天麩羅はちまき
Tempura Hachimaki

地址：千代田区神田神保町1-19
落成年份：1927 年
附註：不只江戶川亂步，井伏鱒
　　　二也常常光顧。店裡也有
　　　他的簽名。

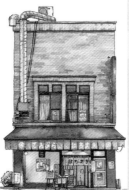

Address:
1-19 Kanda Jimbocho, Chiyoda-ku
Year built: 1927
Note: Not only Edogawa Ranpo,
　　　but Masuji Ibuse would come
　　　here as well. His autograph is
　　　here too.

09 誠心堂書店
Seishin-do Bookstore

地址：千代田区神田神保町2-24
落成年份：1950 年代
附註：據說曾有電影在這棟迷人
　　　的建築取景拍攝。

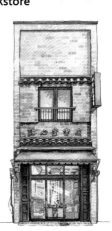

Address:
2-24 Kanda Jimbocho, Chiyoda-ku
Year built: 1950's
Note: This charming building has
　　　apparently been used as a
　　　location for movies.

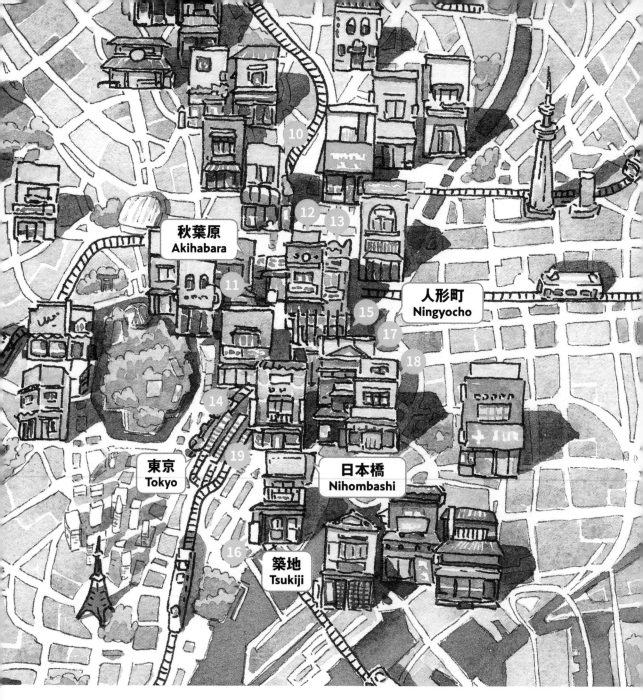

秋葉原
Akihabara

人形町
Ningyocho

東京
Tokyo

日本橋
Nihombashi

築地
Tsukiji

10	北海麵包店	Hokkai Bakery	034
11	日米無線電機商會	Japan-US Transceiver Company（Radio Garden）	036
12	岡昌襯裡鈕扣店	Okasyou Linings&Buttons Shop	038
13	海老原商店（歇業/私人住宅）	Ebihara Shōten（Closed/Private-house）	040
14	榮屋牛奶堂	Sakae-ya Milkhall	042
15	江戶屋	Edo-ya	044
16	中央物流株式會社	Chuo-butsuryu Inc.	046
17	生毛屋	UBUKEYA	048
18	壽堂	Kotobuki-do	050
19	大勝軒	Taishō-ken	052

店鋪資訊02　Shop Notes 02 　054

第2章
Chapter2

日本橋
Nihombashi
地區
Area

秋葉原
Akihabara

10 北海ベーカリー
Hokkai Bakery

湯島 Yushima　北海麵包店

這家小小的三明治店座落在秋葉原北邊的湯島站附近。紅、白、藍相間的遮雨棚和茂盛的盆栽是這家店的特色。有時候在路上會看見盆栽茂盛蓬勃到有如一座迷你叢林的店家，這家小小麵包店的門口和陽台也不例外。

Hokkai Bakery is a small sandwich shop near Yushima Station in the north side of Akihabara. This shop is distinguished by its red, white, and blue eaves, as well as its lively plants. I sometimes see shops whose plants have grown so much that they have become small jungles, and the front and balcony of this little bakery are no exception.

壓克力製的頂棚。雖然並不是高級材質，但是我很喜歡陽光透過這種頂棚，為棚下空間蒙上一層色彩的氛圍。

Roof with acrylic sheeting. Although it is not really high-class, I like how roofs like this color the things underneath them when hit by the sunlight.

櫥窗內的手寫價目表。前方的印花窗簾是用來遮擋西曬的。

A hand-written price list in the shop window. There is a floral curtain in the foreground that is used as a sunblind.

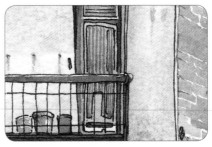

窗型冷氣。日本的夏天相當炎熱，我本來以為這類小台簡易型冷氣機處處可見，但是以管線連接室內外的大型分離式冷氣似乎才是家家戶戶的標準配備。

In-window airconditioning unit. As Japan gets really hot in the summer, I thought there will be units like this everywhere, but air conditioning systems connecting the inside and outside units by pipes seem to be the standard.

我總是無法理解，為什麼花盆這麼小，盆栽有時候卻長得又高又茂盛。

I always wonder how these small potted plants sometimes get this big and lively.

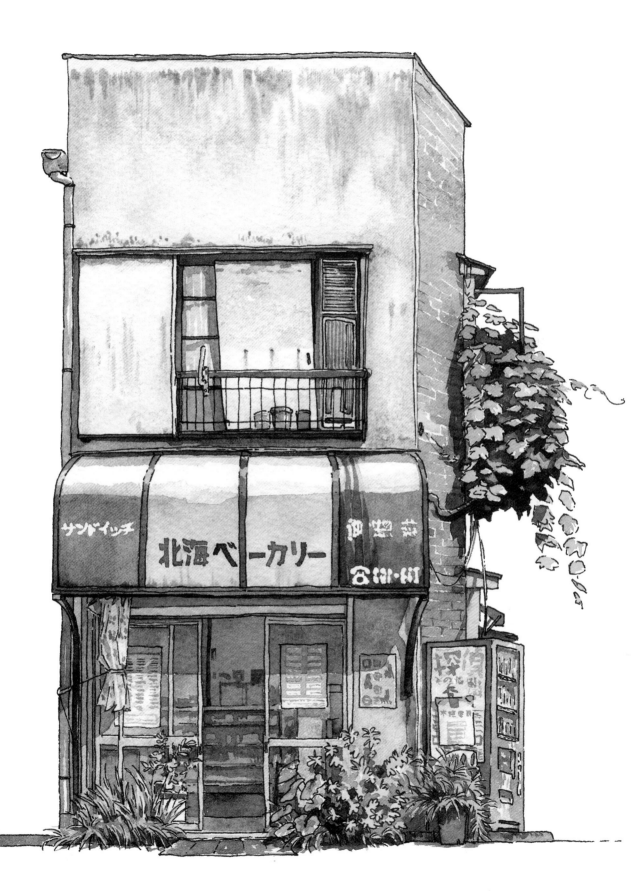

11

日米無線電機商会(ラジオガァデン)
Japan-US Transceiver Company (Radio Garden)

秋葉原鐵道橋下的電子零件專賣店。秋葉原是東京的著名區域，到處都是便宜的電器產品和動漫等流行文化。這家店的一大魅力是位在鐵道橋下方，因此我也把鐵道橋加入畫面。

This is an electric parts shop under the railway bridge in Akihabara. This famous area of Tokyo is filled with electronics, cheap items, and pop-culture such as anime and manga. One of the charms of this place is that it is located under a railway bridge, so I included it in the painting.

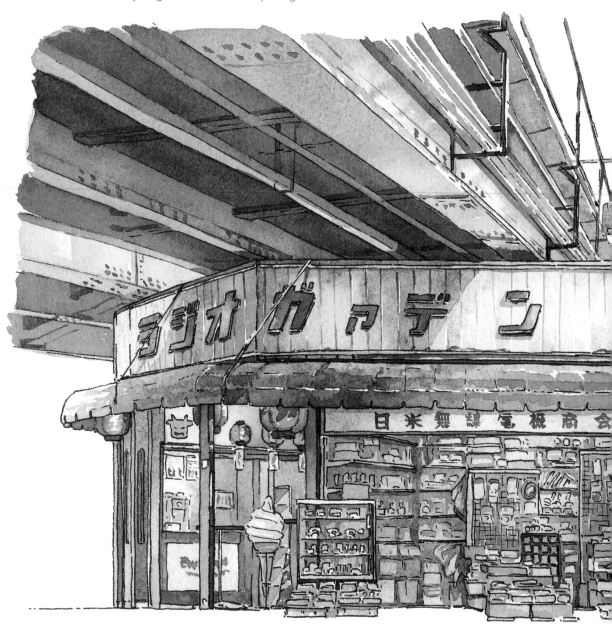

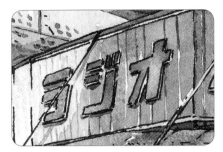

招牌上寫著「ラジオガァデン」，意即「無線電廣場」，是該區商業設施的集合名稱，過去在同個屋簷下曾有許多專賣收音機和電子零件的商店。然而如今只剩下這家店。順帶一提，隔壁是有名的炸豬排三明治店。

A sign reading "Radio Garden". Radio Garden is the collective name of the facilities, which once were a group of stores carrying radios and electric parts under one roof. Currently, however, only this shop remains. Incidentally, the shop next door is a famous pork cutlet sandwich shop.

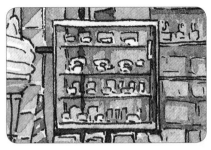

擺滿各式喇叭的玻璃櫃。

A glass case full of various kinds of speakers.

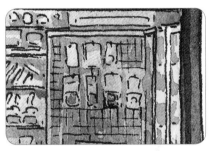

各種品牌和尺寸的電腦冷卻風扇。

Computer cooling fans of many brands and sizes.

小盒子和箱子裡放滿各種電子零件。有些現在不易取得的少見零件在這裡也能買得到。

Many different electronic parts in small boxes and containers. Some unusual parts that are difficult to obtain now are also sold.

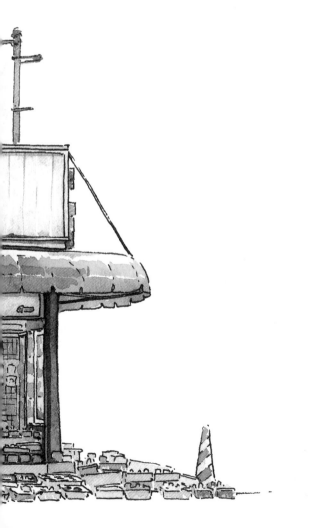

12

岡昌裏地ボタン店
Okasyou Linings&Buttons Shop

店家正面外牆鍍了一層銅，裡面則堆滿了賞心悅目的漂亮鈕扣。商店柱子上掛著門牌，寫有地址。日本的地址並非以街道名稱為準，建物的號碼也可能是隨機的，因此有掛門牌幫了大忙。

Many delightful buttons are crammed together in this shop, whose front is copper plated. The pillar of the shop has a plate displaying its address. In Japan, addresses are not based on street names, and building numbers can be rather random, so these plates are a huge help.

由於招牌的字樣搖搖欲墜，因此已經拆下，現在店鋪牆面只剩下淒涼黯淡的痕跡。我利用店主為我們畫的草圖重現當初的招牌字樣。

The letters of this sign have been taken down because there was a risk of them falling. Now, only sad, dark marks remain on the front of the building. I recreated this based on a sketch made for us by the owner.

這一區塊兩側的空間用來收納稱為「雨戶」的拉門式窗板。

These parts are used as a storage for the sliding window shutters called *amado*.

巨大的櫃子展售多種鈕扣和線。

Huge cases selling various kinds of buttons and threads.

小貼紙上寫著「11 月 22 日是鈕扣日」。店主的腳踏車從防雨罩探出一角。

Small sticker saying that November the 22nd is Button Day. The owner's bicycle is peeking out from inside the rain tarp.

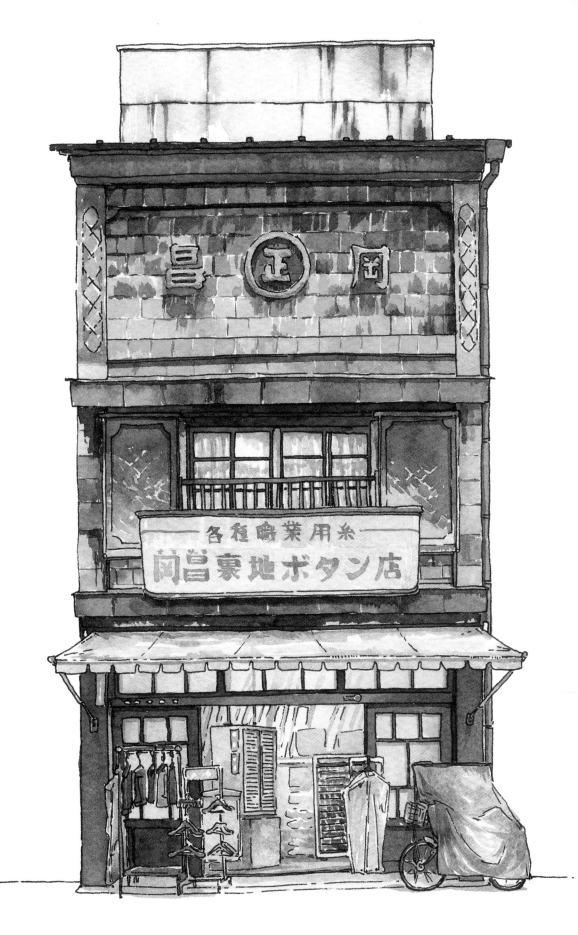

13

秋葉原 Akihabara　海老原商店

海老原商店 （歇業／私人住宅）
Ebihara Shōten （Closed/Private-house）

海老原商店過去似乎曾是男裝布料店。據說原本要拆除，但是經過現任主人的努力，為這棟建築進行局部整修，目前仍維持最初的樣貌。店家正面鋪滿華美的金色磁磚。這家店和岡昌襯裡鈕扣店座落在同一條街上。

Apparently, Ebihara Shōten was once a menswear fabrics shop. There was talk of demolition, but through the effort of the current owner, part of the building was refurbished and currently maintains its original appearance. Beautiful golden tile covers the front of the shop. This shop is located on the same street as Okasyou Linings&Buttons Shop.

鍍銅的美麗山形牆。

Beautiful pediment covered in copper.

店內的燈光，透過玻璃形成漂亮的波紋。

The light from inside the shop creates patterns through the glass.

招牌的拉丁字母排列方式相當少見。字母之間的怪異距離是配合店名的日語發音：「E-BI-HA-RA」。但是對於知道什麼叫做「字距」的人，看了真是很頭痛呀。

A sign in Latin script letters in quite unusual style. The weird spacing of the letters matches the syllables in the Japanese pronunciation of the store name: "E-BI-HA-RA". This will give a headache to all those people who know what the word "kerning" means.

入口原本有一個小小的捲式遮陽棚，不過最近翻新時拆下來了。正面牆上仍能見到原來的金屬裝置。

There was a small roll-up roof shading the entrance, but it was taken down during the recent renovations. You can still see the metal support elements on the facade.

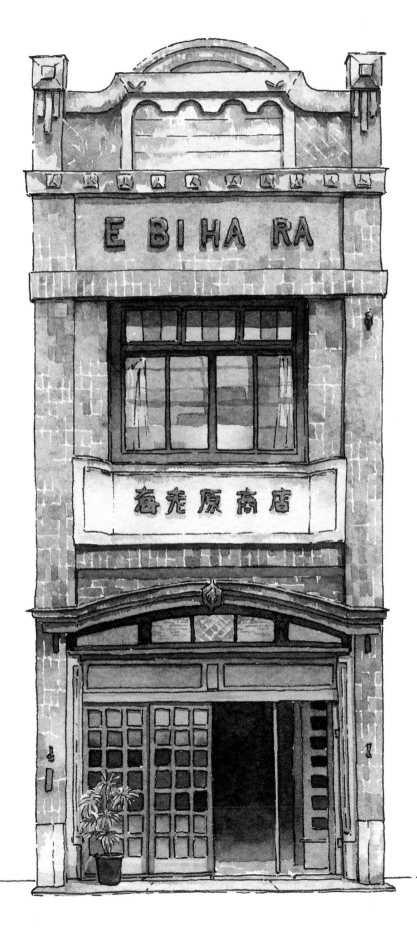

神田 Kanda 榮屋牛奶堂

14 栄屋ミルクホール
Sakae-ya Milkhall

「ミルクホール」（Milkhall）是指供應牛奶的咖啡店，過去在增進國民體格的政策下風行日本全國。目前店面為一般的餐廳，徒留昔日店名。這家店有許多充滿玩心的細節，包括外帶櫥窗裡排排站的飯糰、金屬信箱，以及幾可亂真的展示用食物模型。

A milk hall is the name given to cafes where people could drink milk, which spread nationwide under a policy of strengthening the Japanese physique. Currently operating as a restaurant, only the name "Milk Hall" remains here. This shop has many delightful details, including a line of rice balls at the takeout counter, the metal post-box, and realistic fake food samples on display.

正如招牌上寫著「輕食・喫茶サカエヤ」，這家餐廳現在販售拉麵和咖哩飯，不過暖簾上還是寫著大大的「ミルクホール」。

As the sign, which reads "Light Meals & Café Sakae-ya", says, this is currently a restaurant serving ramen and curry, but the *noren* curtain has the words Milk Hall in big letters.

店鋪正面鍍銅的綠色幾乎完全繡化了。左側牆面是新的，或許是隔壁建築拆除時重砌的吧。

The copper coating on the front of this shop almost completely lost it's green color. The wall on the left side is new. Perhaps it was replaced when the next door building was demolished.

左側櫥窗裡陳列著可以外帶的飯糰。展示櫃上方有一個小小的玻璃滑門，這樣一來，不必進入店內就可以直接拿取。右側櫥窗則展示一些小玩具和招財貓，吸引顧客入店。

A display featuring some things you can buy on the go, like *onigiri* (rice-balls). There is a small sliding window above the display so you can get takeout without entering the shop. There are also some small toys and *maneki-neko* (lucky cat) beckoning customers in.

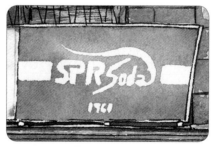

我蠻喜歡這個印在金屬看板上的氣泡飲料招牌，即便這也許是整棟建築最不具日本特色的部分。不知為何，這些招牌總是令我產生鄉愁情懷。

This is maybe not the most Japanese feature of the building, but I kind of like the fizzy drink sign printed on metal. I don't know why, but they give a nostalgic retro vibe.

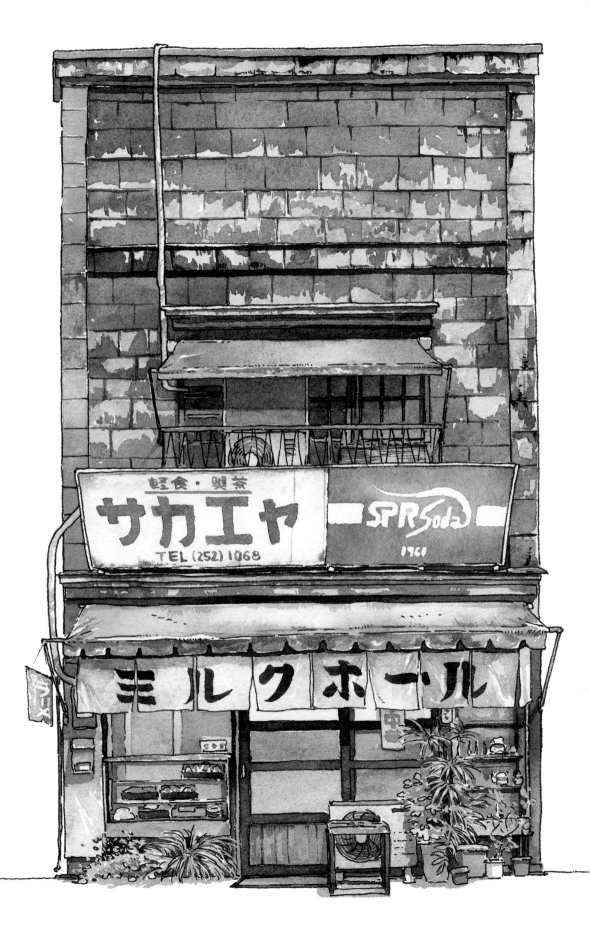

人形町 Ningyocho　江戸屋

15 江戸屋 Edo-ya

江戶屋於1718年成立，專賣日式和西式刷具，是本書中歷史最悠久的店家，這點也讓它與眾不同。江戶時代，此處販售日式排刷，不過從明治時代起，開始販賣西式筆刷。最近他們推出的女性化妝刷具也很受歡迎。江戶屋的外部（以及店內！）最近費了一番工夫翻新，因此我們前來拍照時，整間店看起來幾乎像新的一樣。

Founded in 1718, this specialty brush shop stands out as having the longest history of any in this book. During the *Edo* Period it was a *hake* (Japanese-style brush) shop but started carrying Western-style brushes starting in the *Meiji* Period. Recently, their makeup brushes for women are popular as well. The front of this shop (and the inside, too!) was recently painstakingly renovated, so it looked almost brand new when we came to take photos.

這些奇特的垂直裝飾有如硬挺的刷毛！

These weird vertical elements are made to look like bristles of a brush!

這棟建築也有一塊牌子，證明市政府將其登錄為重要文化資產。

This building also had a plaque stating that it has been registered by the city as an important cultural property.

店內的天花板掛著許多種類的刷具。這類手工製刷具必須存放在通風良好的環境。

Inside the shop there were many kinds of brushes hanging from the ceiling. Hand-made brushes of this type have to be stored in a well ventilated environment.

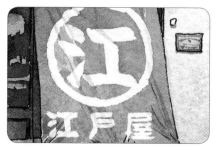

天氣晴朗時，門外會掛起有店徽的巨大簾子，保護店內避免陽光直射。這種簾子叫做「日よけ暖簾」，即遮陽暖簾。

This huge curtain with the shop logo is put outside in good weather to protect the interior from direct sunlight. It's called a *hiyoke noren*, or anti-sun curtain.

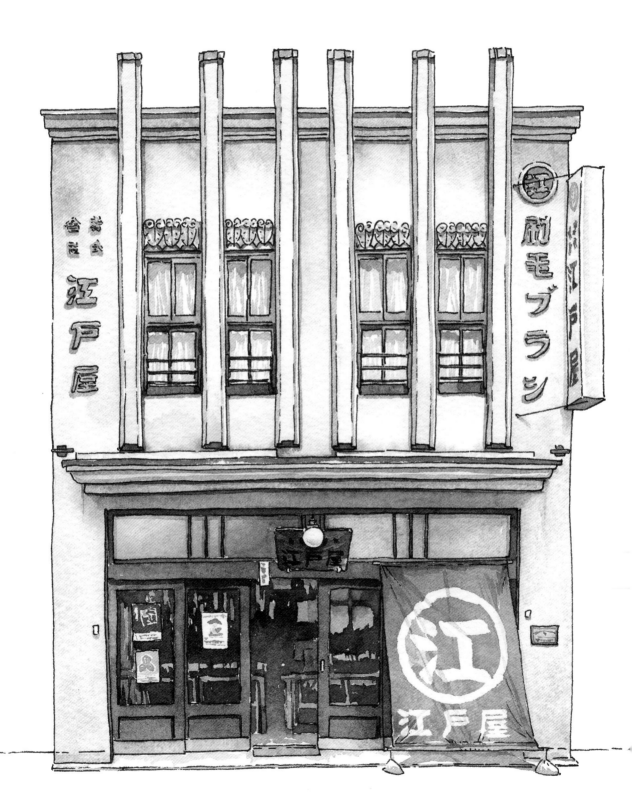

16 中央物流株式会社
Chuo-butsuryu Inc.

入船 Irifune 　中央物流株式會社

中央物流株式會社是一家貨運公司。最先抓住我目光的是停放在店內的叉式起重車，然後才是招牌上密密麻麻的字。最前面掛著地方陸運局的許可執照，入口則是一塊厚實的金屬板，緩衝門檻高低差，方便車輛駛入。

Chuo-butsuryu Inc. is a freight company. The forklift stowed inside the store was what caught my eye first. The next was the sheer number of characters on the sign. In front is the District Land Transport Bureau License, and at the entrance is a thick metal plate making it easier for vehicles to enter.

這塊形狀奇怪的屋頂建材沿著建築物側面向下延伸。可能是隔壁店家拆除後遺留下來的。

This weird shape here is part of the roofing material running along the side of the building. This is probably a leftover feature from the shop next door that was demolished.

隔壁的建築物拆除後，蓋了一棟投幣式停車場。這個防撞柵欄可在車輛出入時保護店家。

A coin-operated parking lot was put up after the building next door was demolished. This is a bumper to protect the shop from cars coming in and out.

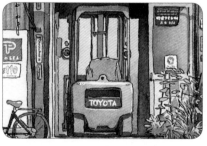

窄小建築裡的叉式起重車。我無論如何都想要把這個畫出來。店內深處是明亮的辦公空間。

A forklift inside a small building. I simply had to paint this. There is a brightly lit office space deeper inside the building.

塑膠瓶裝水。關於為何在建築物旁邊放一瓶水，理由眾說紛紜。普遍說法是，這些水瓶的功能有如廉價的交通錐，或是用來驅趕貓（不過意外的是，許多貓和這些水瓶相安無事）。

A plastic bottle full of water. There are many theories as to why people put them near buildings. The most common ones are that they serve as cheaper traffic cones or as a cat repellent (though a surprising number of cats are fine with them).

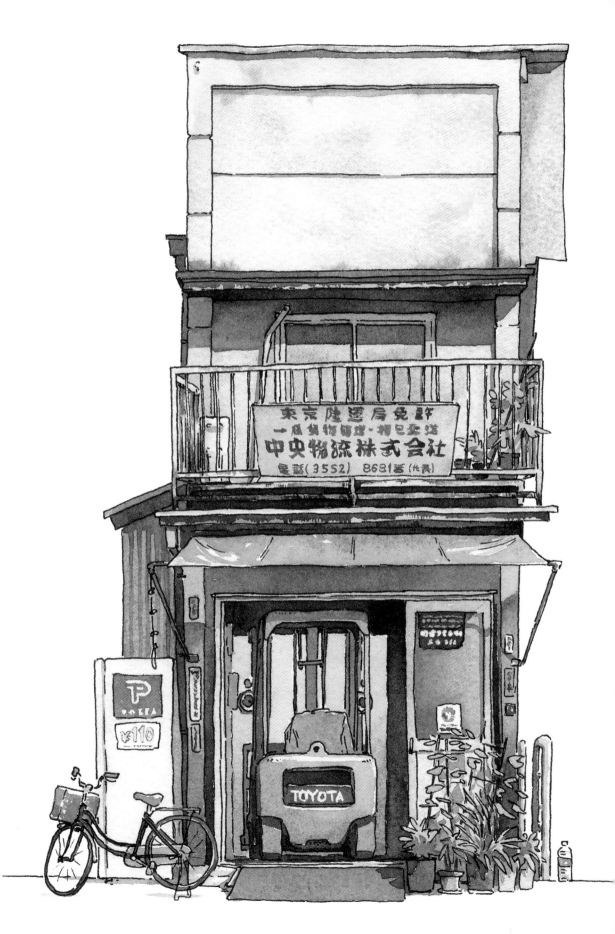

17 うぶけや UBUKEYA

（人形町 Ningyocho）生毛屋

成立於1783年的刀具專賣店，販售廚刀、剪刀、刮鬍刀、除毛夾，以及其他商品。這家店源自大阪，19世紀時拓展到東京（當時的江戶），60年後落腳目前的店址。店鋪外觀維持最初的樣子，不過1975年曾經翻新過。時至今日，店家似乎仍使用著過往流傳至今的店內展示架，並且保留了傘狀天花板樣貌。

UBUKEYA is a blade specialty shop established in 1783. They carry knives, scissors, shaving razors, tweezers, and more. Originally from Osaka, this shop expanded to Tokyo (*Edo*) in the 19th century and settled at its current location 60 years after that. The exterior maintains its original appearance but was renovated in 1975; however, they appear to still use the original inside display shelves and the traditional umbrella-like ceiling to this day.

前方櫥窗展示的是《江戶品味與優雅名產之比較》（大江戶趣味風流名物くらべ）。這本書寫於明治維新期間，介紹許多名店。本店當然也在名單上。

Displayed at the front is *A Comparison of the Tasteful and Elegant Specialties of Edo*. Created during the *Meiji* Restoration, this book featured a list of recommended shops. Of course, Ubuke-ya is listed.

這塊巨大的招牌氣派極了！飽經風霜的木頭、鍍銅的屋頂、木雕的招牌架，還有綠色的「う・ぶ・け・や」字樣（如同許多日式老招牌，書寫方式是從右到左）。風格獨具的燈在傍晚時照亮招牌。

This huge sign is just gorgeous! The weathered wood, copper-covered roof, carved stand, and green letters reading U・BU・KE・YA (read from right to left, as with most old Japanese signs). Stylish lamps light up the sign in the evening.

深褐色的厚重拉門要費些力氣才能推開。這類型的店鋪與這種大門相當匹配。

These heavy, dark brown sliding doors require some effort to pull open. A proper entrance for a shop like this.

我們來探勘店家時，門外正好擺了一盆小蘋果樹的盆景，上面還結了小蘋果呢。

There was a *bonsai* apple tree with small apples on it outside the shop while we were scouting the location.

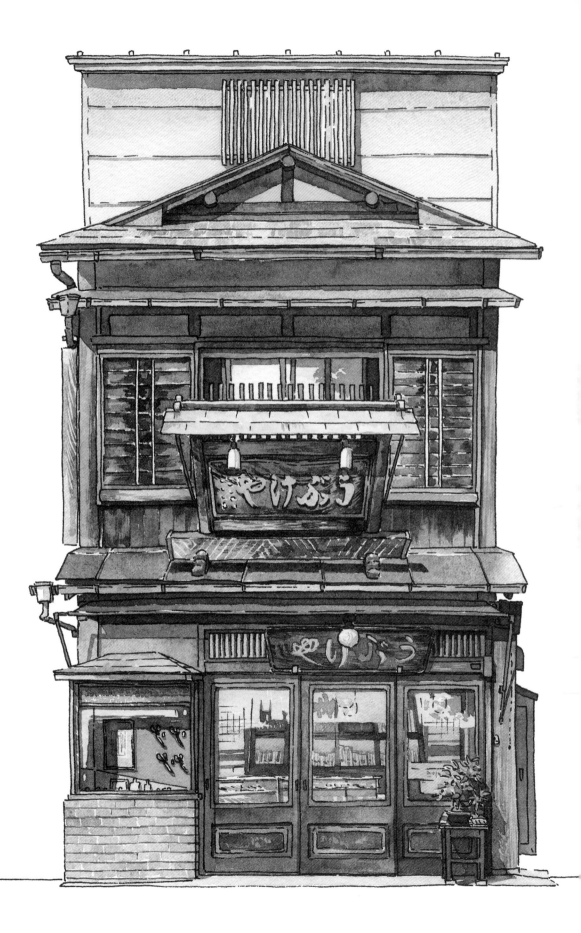

水天宮 Suitengu　壽堂

18 壽堂 Kotobuki-do

壽堂是水天宮一帶的傳統和菓子店。櫥窗不只展示店內販售的和菓子，隨著不同季節也會更換人偶和花的陳設。店家正門有一塊長長的暖簾，這麼長的暖簾相當罕見呢。

Kotobuki-do is a traditional Japanese sweets shop in Suitengumae. The display window features not only the Japanese sweets they sell, but dolls and flowers decorated for the season. At the main entrance to the shop is a long *noren* curtain. Seeing one this long is actually quite rare.

這座燈籠很可惜已經不在了——只留下支架。我在網路上搜尋到舊照片，並在插圖中重現。

This lantern is sadly no longer there - only the support bar remains. I managed to find some old photos online to recreate it in my illustration.

廚房的門。漂亮的和菓子就在一樓後面和二樓製作而成。

The service door. The wonderful sweets are made on the first floor in the back and on the second floor.

我很喜歡這家店正面層層往上變窄的樣子。

I like how the front of the shop gets narrower and narrower with each floor.

店鋪正面灰藍色的牆面襯著紅色窗框，配色大膽獨特，非常搶眼。

The red of the window frames looks fantastic on the blue-gray front of the shop.

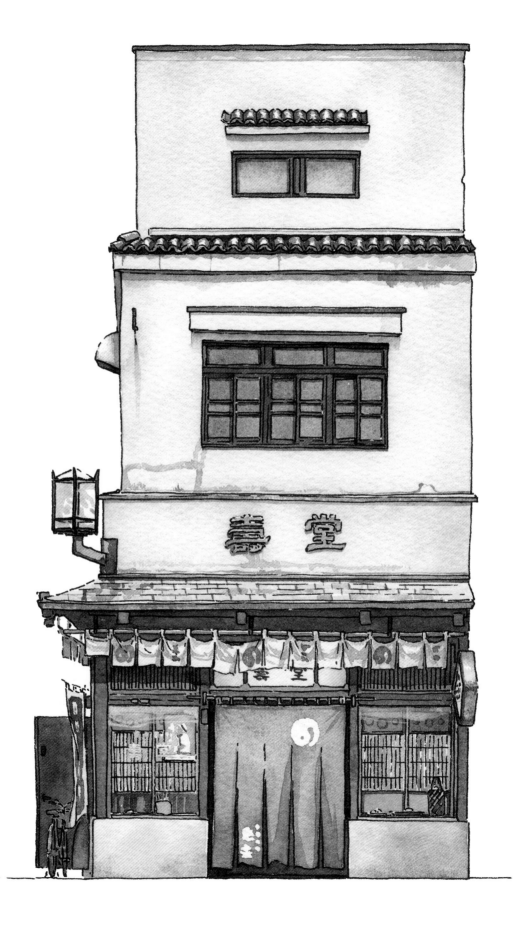

(三越前 Mitsukoshimae)　大勝軒

19 大勝軒 Taishō-ken

大勝軒是日本橋附近的中式餐廳。這家復古小店建於商務大樓區，非常醒目，因此據說許多人經過時都會拍照或畫下速寫。店家正面最初是在建築物的左側，但是經過多次翻新，變成現在入口朝向大街的配置。

Taishō-ken is a Chinese restaurant in Nihonbashi. Built in an office area, this retro shop really stands out, so many people snap photographs while passing or sketch pictures of it. At first, the front of the shop was on the left side of the building, but after many renovations it reached its current layout with the entrance facing the bigger street.

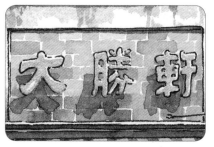

店家的金色招牌不復存在，擔心地震造成危害因此拆除了。店主拿了餐廳剛開業時的舊照片給我看，我以此為依據畫下字樣。

This shop's golden letters are no longer there, taken down for fear of earthquakes. I painted them based on old photos the owner showed me from when the restaurant first opened.

這是屋頂的出口。雖然餐廳四周現在高樓林立，不過剛開業時想必視野一定很好。

This is the exit to the roof. While the restaurant is currently surrounded by towering buildings, it probably had a nice view when it opened.

根據店主借我看的照片，我也畫上招牌周圍原本的中式裝飾邊框。

Based on the owner's photos I also added this Chinese-looking pattern that was originally around the sign.

折疊式傘架，以備雨天之需。

A folding umbrella stand for rainy days.

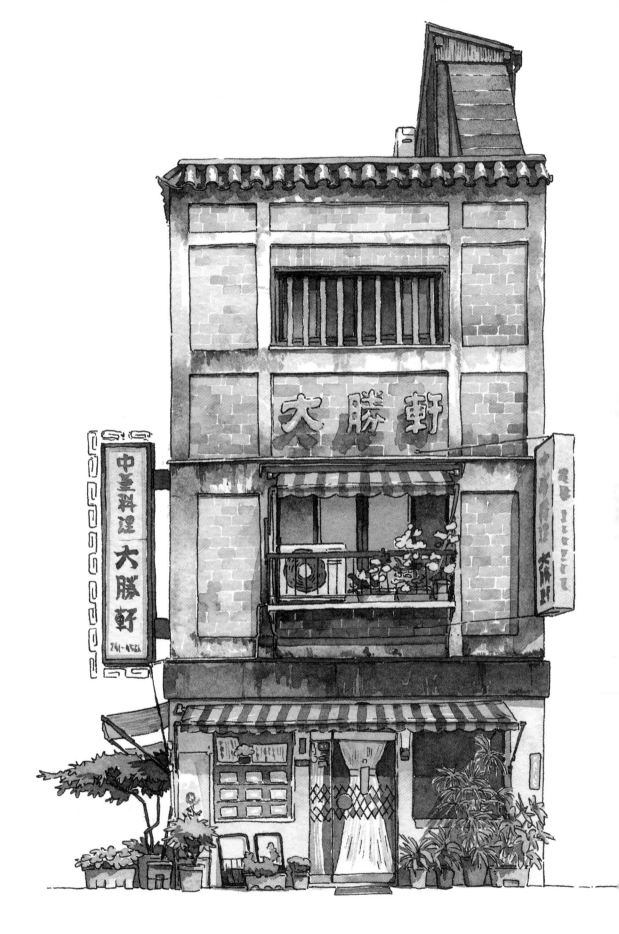

店鋪資訊
02
—

10 北海ベーカリー Hokkai Bakery

地址：千代田区外神田6-9-3
落成年份：1950 年
附註：店名的「北海」是因為初
　　　代店主來自北海道。

Address:
6-9-3 Sotokanda, Chiyoda-ku
Year built: 1950
Note: The name Hokkai comes
from the fact that the
original owner was from
Hokkaido(北海道).

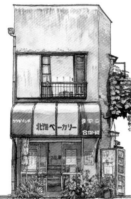

11 日米無線電機商会（ラジオガァデン）
Japan-US Transceiver Company (Radio Garden)

地址：千代田区神田須田町1-25
落成年份：1947 年左右
附註：這家店有許多死忠粉絲，到秋葉原時總會
　　　造訪此處。

Address: 1-25 Kanda Sudacho, Chiyoda-ku
Year built: around 1947
Note: This shop has many hardcore fans who always pay
a visit when they come to Akihabara.

12 岡昌裏地ボタン店
Okasyou Linings&Buttons Shop

地址：千代田区神田須田町2-15
落成年份：1928 年
附註：因建築物本身的重量導致
　　　凹陷變形的天花板也是必
　　　看細節。

Address:
2-15 Kanda Sudacho, Chiyoda-ku
Year built: 1928
Note: The sight of the ceiling
warping under its own
weight is a must-see.

13 海老原商店（歇業 / 私人住宅）
Ebihara Shōten (Closed/Private-house)

地址：千代田区神田須田町2-13
落成年份：1928 年
附註：掀起一樓的地板，就會露
　　　出早期的防空洞！

Address:
2-13 Kanda Sudacho, Chiyoda-ku
Year built: 1928
Note: Lift up the flooring on
the first floor to reveal an
old bomb shelter in the
basement!

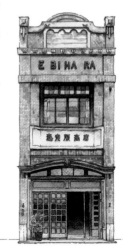

14 栄屋ミルクホール
Sakae-ya Milkhall

地址：千代田区神田多町2-11-7
落成年份：1920 〜 30 年代
附註：在這家昭和懷舊風的店家
　　　吃一碗拉麵，感受絕佳的
　　　美味！

Address:
2-11-7 Kanda Tacho, Chiyoda-ku
Year built: 1920s - 30s
Note: The ramen at this retro,
Showa-style shop is exquisite!

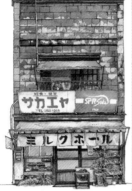

15 江戸屋 Edo-ya

地址：中央区日本橋大伝馬町2-16
落成年份：1925 年
附註：店裡大約藏有3000
　　　種刷具呢！

Address:
2-16 Nihombashi Ōdenmacho,
Chuo-ku
Year built: 1925
Note: Carries roughly 3,000
kinds of brushes!

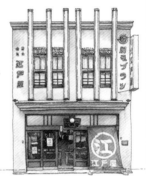

16 中央物流株式会社
Chuo-butsuryu Inc.

地址：中央区入船2-5-6
落成年份：1930 年
附註：店裡不僅有一台叉式起重
　　　車，通常還有一輛小貨車！

Address: 2-5-6 Irifune, Chuo-ku
Year built: 1930
Note: Usually, not only is there a
small forklift parked in
the building but also a small
truck!

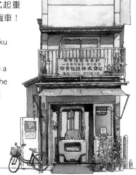

17 うぶけや UBUKEYA

地址：中央区日本橋人形町3-9-2
落成年份：1927 年（1975 年重建）
附註：店家的標語是「本店切不斷
　　　的只有我們的除毛夾，以及
　　　與顧客的連結」。

Address:
3-9-2 Nihonbashi Ningyocho,
Chuo-ku
Year built: 1927 (Rebuilt in 1975)
Note: The shop's slogan is, "The
only items at Ubukeya that
don't cut are our tweezers and
our bonds with customers".

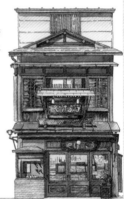

18 壽堂 Kotobuki-do

地址：中央区日本橋人形町2-1-4
落成年份：1926 或 1927 年左右
附註：店裡飄著濃郁的肉桂香氣。

Address:
2-1-4 Nihonbashi Ningyocho,
Chuo-ku
Year built: Around 1926 or 1927
Note: The scent of cinnamon
wafts inside the shop.

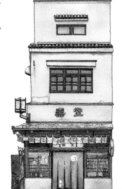

19 大勝軒 Taishō-ken

地址：中央区日本橋本町1-3-3
落成年份：1957 年左右
附註：鐵窗以前似乎是鮮豔的朱
　　　紅色。

Address:
1-3-3 Nihonbashi Honcho,
Chuo-ku
Year built: Around 1957
Note: Apparently the window
railing used to be a vivid
vermillion in the past.

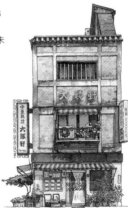

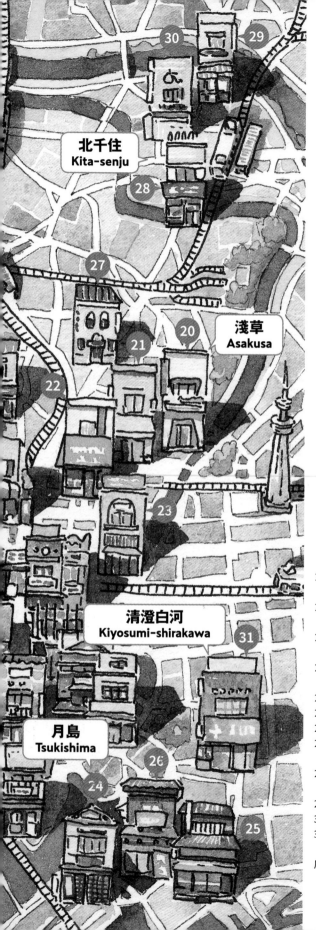

北千住
Kita-senju

淺草
Asakusa

清澄白河
Kiyosumi-shirakawa

月島
Tsukishima

20 岡添耳鼻咽喉科眼科醫院
 Okazoe Otolaryngology&Ophthalmology ·················· 058
21 小泉坐墊屋（已拆除）
 Zabuton Koizumi（Demolished）·················· 060
22 菊屋橋照相館
 KIKUYABASHI Camera Corner ·················· 062
23 金桝屋氣球專賣店（已拆除）
 Kanemasu-ya Rubber Store（Demolished）·················· 064
24 植村屋 Uemura-ya ·················· 066
25 佃屋酒店 Tsukuda-ya Liquor Shop ·················· 068
26 天安 Tenyasu ·················· 070
27 矢島照相館（歇業/私人住宅）
 Yajima Photo House（Closed/Private-house）·················· 072
28 道產子千住一丁目店 Dosanko Senju-1chome ·················· 074
 一內部展開圖 Inside View
29 鮒秋 Funaaki ·················· 078
30 菊屋機車行 Kiku-ya Motors ·················· 080
31 小島藥局 Kojima Pharmacy ·················· 082

店鋪資訊03 Shop Notes 03 ·················· 084

第3章
Chapter3

北千住
Kita-senju

淺草
Asakusa

地區
Area

2 0

岡添耳鼻咽喉科眼科医院
Okazoe Otolaryngology&Ophthalmology

這間診所位在西淺草，許多當地居民都到此就診。我喜歡這棟建築的獨特外牆，因此決定畫進本書。我也好愛二樓窗戶上的金色大字，既是漂亮的細節，畫起來也很享受！

This clinic is located in Nishi-asakusa and is visited by many locals. I like its unique façade, so I decided to feature it here. Also, I just love those huge, golden yellow letters on the second story window. Such a nice detail and a lot of fun to paint!

捲式遮陽棚是後來加上的，沿著診所座落的商店街，每家店都統一裝在相同的位置。我一度猶豫是否該畫出來，不過因為植物和設計都很有意思，後來還是決定呈現這部分。

This roll-up roof was added later and extends throughout the entire shopping street where this shop is located. I was hesitant if I should paint it here, but decided to feature it because of the plants and its interesting design.

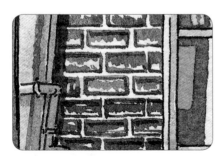

這部分並不是磁磚，而是玻璃磚。厚實但透光，造型感十足。

This part is not tile, but glass blocks. Thick yet translucent, these blocks are rather stylish.

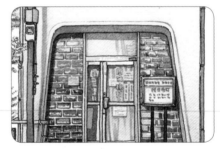

我的妻子香苗告訴我，這家店的形狀看起來有如拔下來的牙齒。我覺得確實有點像。可惜這家小診所專看耳鼻喉科和眼科。

Kana told me that the shape of this shop makes it looks like a pulled tooth. I guess it does, a little. It's a shame this small clinic specializes in ears and eyes.

門診時間表有專屬的架子，裝在金屬框和玻璃面板裡。我很高興並不是看到一張單薄的紙或塑膠告示牌貼在牆面上的景象。

The time schedule has its own stand with a metal frame and glass front. I appreciate the fact that it is not just a paper or plastic sign on a wall.

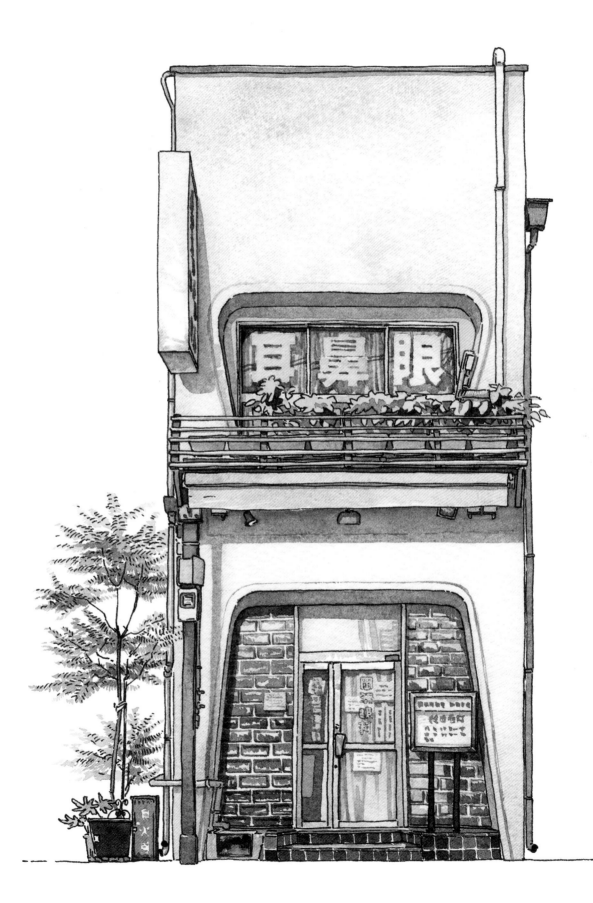

21

淺草 Asakusa　　小泉坐墊屋

座ぶとんのこいずみ (已拆除)
Zabuton Koizumi (Demolished)

這是一家「座ぶとん」（坐地板時使用的日式坐墊）專賣店。店家所在的淺草一帶有許多日式料亭和居酒屋，因此或許這裡的坐墊需求量頗高。兩側的招牌看起來相當老舊。其中左側的招牌不是印在白色塑膠上，而是紅色塑膠割字貼上去的。即使已經褪色，我還是很喜歡這塊招牌。

This is a *zabuton* (Japanese cushion used for sitting on the floor) specialty shop. In Asakusa, where this shop is, there are many Japanese-style restaurants and pubs, so perhaps there is high demand for *zabuton* cushions. The signs on either side appear to be quite old. One can tell by the way the letters are not printed on the white plastic, but cut out and pasted to the base. I like this sign despite its faded colors.

我就是很愛畫字很大、對比大膽強烈的店面！

I simply love to paint storefronts with bold, huge, contrasting letters!

袋子裡塞滿類似泡棉的坐墊填充物。

A bag containing the sponge-like filling for the *zabuton*.

這家店的內部共有三層空間：可以穿著鞋子進入的區塊、墊高並鋪有疊蓆的工作處，以及更高的部分，或許只有員工才能踏足。

The interior of this shop has three floor levels: a part you could enter with your shoes on, a raised workspace with a tatami mat, and an even higher raised part, probably only for personnel.

店家在旁側裝了一個水龍頭。

A water faucet installed at the edge of the shop.

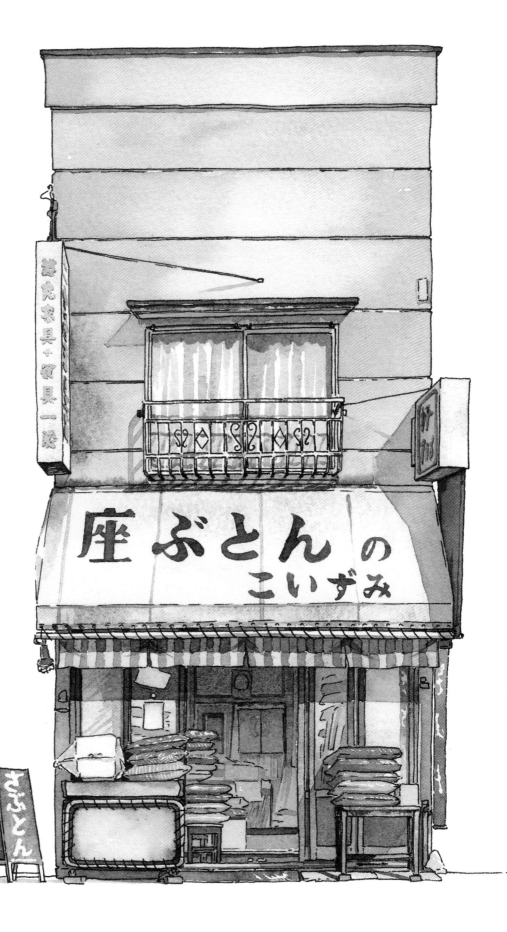

2 2

元淺草 Moto-asakusa　菊屋橋照相館

菊屋橋カメラコーナー
KIKUYABASHI Camera Corner

如店名所示，這家相機店座落在面向大街的轉角，就在合羽橋道具商店街上，周圍有許多料理用具店。我尤其喜歡外牆上那一道垂直的藍色磁磚。

As the name suggests, this camera shop sits on a corner facing a large street. It is on *Kappabashi Dogu* Street along with many cooking utensil shops. I especially like the vertical stripe of the blue tiles on the outer wall.

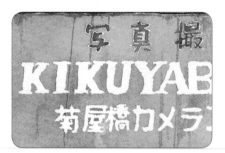

這裡原來有另一個商標──一個相機公司的標誌。可惜因為商標已經年代久遠，公司也不再使用，因此我無權畫進本書。我決定以店家原始的商標字體取代，實際上和綠色遮雨棚底下的字體是一樣的。

There was a different logo here - a photography company's mark. Unfortunately, because the logo is old and no longer used by the company I was not allowed to feature it. I decided to replace it with the shop's original logotype identical to the one we actually found underneath the green marquee.

直條的帶狀牆飾由深藍色磁磚砌成，使店面特別顯眼。

The vertical stripe made of deep blue tile is what makes this shopfront really stand out.

櫥窗裡有華麗迷人的老式刻花玻璃燈，以及相機公司的品牌看板。

There were some really gorgeous, vintage cut-glass lamps and brand signs in the display window.

店面櫥窗的架子上擺滿照片、相框、相機，多到幾乎看不見裡面。

The front window was so full of shelves with photos, frames, cameras, and more that it was almost impossible to see the inside.

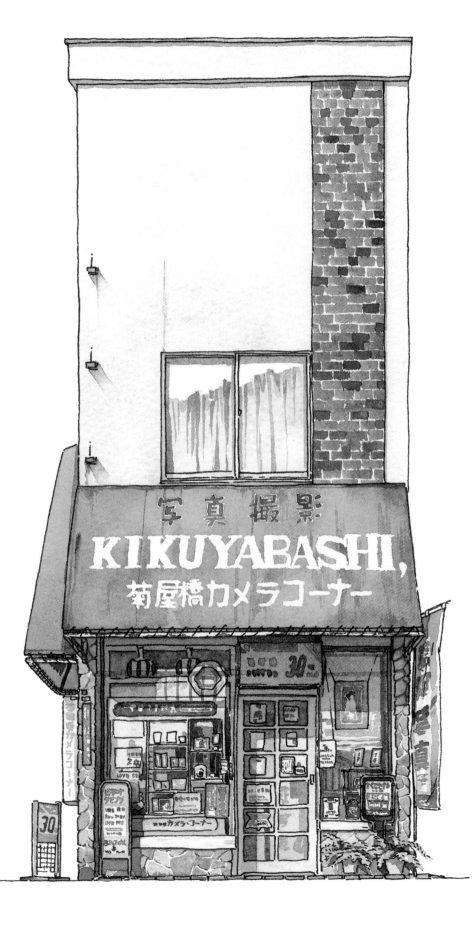

23

藏前 Kuramae 　金桝屋氣球專賣店

金桝屋ゴム (已拆除)
Kanemasu-ya Rubber Store (Demolished)

這家氣球專賣店在淺草橋批發街營業至2018年4月（之後遷址墨田區）。店鋪正面的上半部非常有特色。挑高的窗戶和拱頂，帶有摩登的歐洲氛圍，相較之下金色的招牌卻是典型的日本樣式，兩者的對比使建築更加迷人。

Balloon specialty shop Kanemasu-ya Rubber used to operate in the toy wholesaling town of Asakusabashi (it has since moved to Sumida-ku). The upper front half of the storefront is extraordinary. The high windows and arches create a modern European ambiance. The Japanese gold lettering of the sign makes it even more interesting.

鮮黃色和綠色的遮陽棚，讓商店在繁忙的街道上也不會被忽視。

With its bright yellow and green sunroof the shop really stands out in the busy street.

整片拉門可以推到最右邊，讓整間店面幾乎完全敞開。

These doors can slide over to the right, opening up almost the entire front of the shop.

這家店曾塞滿巨大繽紛的氣球。不過遷址後店裡只剩下寥寥數顆。我回想店家當時的樣子，並在畫中重現店裡滿是氣球的歡樂氣氛。

This store used to be filled with enormous, colorful balloons. Now that the store has relocated, there are only a few of them left. In this illustration, I recreated a fun shop filled with balloons, how it would have been while it was open.

老舊招牌上紅色的文字相當模糊，令人幾乎難以辨認。

Quite worn out, this sign was almost illegible.

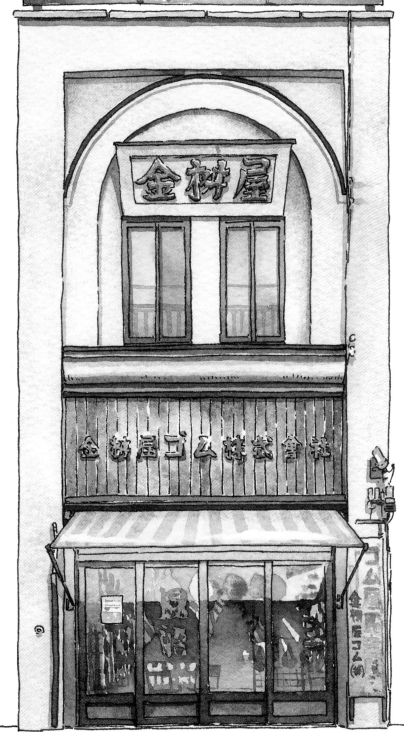

（ 月島 Tsukishima ） 植村屋

24 植村屋 Uemura-ya

月島建立在1890 年完工的填海地上，算是比較新的區域，以文字燒廣為人知。這裡不只有飲食店，還有許多充滿庶民風情的店家，令人備感親切。位在月島的植村屋是一家小巧的布料店。除了販售和服，也提供清洗服務（洗い張り，將和服拆解後清洗上漿，鋪展拉直晾乾的作業）。

Known for *monja-yaki*, Tsukishima is a relatively new town, built on reclaimed land in 1890. Not only are there food and drink establishments, but many shops teeming with a friendly, working-class atmosphere. Here in Tsukishima is Uemura-ya, a small fabric store. In addition to selling *kimonos*, they also do *araibari* (stretching pieces of a *kimono* on boards to dry after they have been washed and starched).

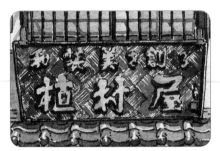

金色字樣的招牌，背景質地相當有趣。有點像鑄造的金屬，刮滿方向不同的方形溝紋。

The background of the gold lettered sign had an intriguing texture. It looked like cast metal with squares grooved in different directions.

這個招牌其實並不在店旁邊，而是在店門口，被茂密的植栽葉片遮住。不過我很喜歡它的造型，因此放進畫面中。

This sign was not actually on the side of the shop but in front of it, obscured by leafy plants. However, I liked the shape of it, so I placed it in the illustration.

店旁的直立布旗是美麗的深藍色。

The banner standing by the side of the shop had a beautiful, deep navy color.

我們來取景時，拉門後面停了一台小汽車，因此畫中可以隱約看見半透明門窗上的映像。

While we were there, location hunting, there actually was a small car parked behind these sliding doors. You can just see it there.

佃島 Tsukudajima　佃屋酒店

25 佃屋酒店
Tsukuda-ya Liquor Shop

佃屋酒店是一家老式洋酒店。雖然佃屋酒店就在植村屋附近，不過所在區域較熱鬧。我到這裡拍照取材時，孩子們就坐在隔壁店門口的地上吃著零食。這種充滿生活感的環境使得店家更有魅力了。

Tsukuda-ya is an old liquor shop. Although it is in the neighboring area, Tsukudajima is located in a little bit more lively area than the neighboring Uemuraya. When I visited to take photographs, children were sitting on the ground in front of the shop next door eating snacks. This lively environment makes the store even more charming.

陽台掛著晾乾的衣物，像這樣的小細節使這家店充滿生活感。每當見到這類景象，我都感到非常開心。

Details like these clothes being hung to dry are what give these shops a more human face. I'm really happy when I find details like this.

老式日本商店和住家常能見到這種結構──後來在建物上加蓋的陽台，只以屋頂支撐，陽台直接立在屋頂的波浪瓦片上。

This is a common sight on old Japanese shops and houses - a balcony added later to the building, supported only by the roof. Here, it stands directly on the *kawara* ceramic tiles.

非常古早的電話和電信服務廣告招牌。之前散步時我就看過幾次類似的招牌，非常開心能夠在本書中畫到一家有這種招牌的店鋪！

A rather old sign advertising telephone and telegram services! I saw it few times before on my walks, so I was very excited to feature a shop with one in this book!

門口張貼著許多手寫的公告，標示販售酒款的名稱和價目表。

A lot of hand written notices and price lists.

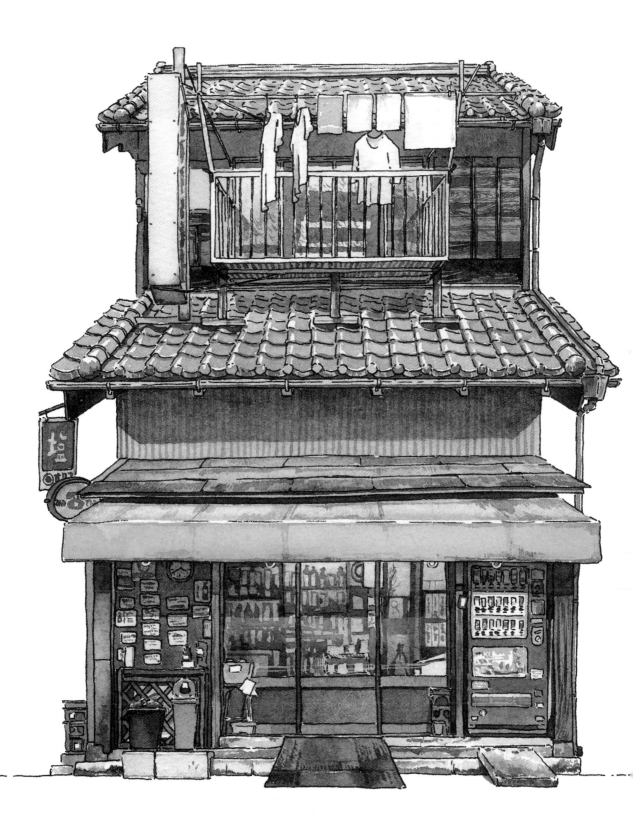

26 天安 Tenyasu

佃島 Tsukudajima　天安

天安於1837年開業,是非常知名的佃煮料理專賣店。「佃煮」是用醬油和糖烹煮至甜鹹入味的蛤蠣或小魚,也是本店所在地佃島的特有料理。店家招牌安穩地放在兩頭獅子造型的木雕動物背上,類似寺廟前的雕像(狛犬)或沖繩的風獅。

Tenyasu is a famous *tsukudani* shop opened in 1837. *Tsukudani* are clams or small fish boiled in soy sauce and sugar till they are sweet and salty, and is a specialty of Tsukudajima, where this shop is located. The shop sign was resting on two lion-like wooden figures similar to the statues in front of temples (guardian lions) or the *Shiisa* from Okinawa.

植物和大片遮陽暖簾後方,有座小小的石燈籠。

There was a small stone lantern (*tourou*) hiding behind the plants and the huge *hiyoke noren* curtain.

這是本書收錄的所有店家中,裝飾最繁複的屋頂之一。漂亮的雨溝槽,屋瓦上還有氣派的家徽裝飾,由此就能看出細緻的工藝技術。

One of the most decorated roofs in all the shops featured in this book. With splendid rain gutters and family crest bearing tiles designed with gorgeous patterns. Fine craftsmanship went into making these.

這系列的店面中,經常能見到傳統日式木造店面和塑膠水管水盆的對比。這間店鋪設計美麗、質樸且歷史悠久,同時卻也能藉此窺見每天的生活痕跡。

The contrast between the traditionally Japanese wooden shopfront and the plastic hoses and tub is something I often see in this series. Yes, the shop is beautifully designed and rustic, but one can see it is being used every day.

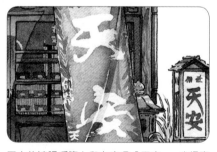

巨大的遮陽暖簾上印有店名「天安」。我很喜歡這張遮陽暖簾,但是現代化印刷的感覺,還有上膠防水布的反光感有點破壞整體景觀。

A huge *hiyoke noren* curtain with the shop name TEN・YASU printed on it. I like the *hiyoke noren*, but feel that the modern print on a rubberized fabric reflects light and spoils the effect a little.

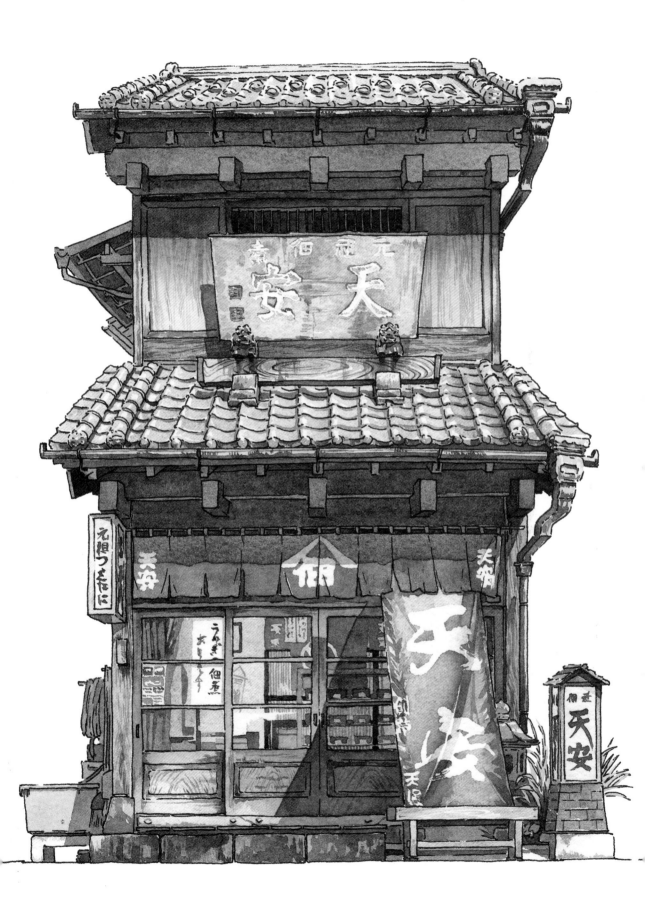

根岸 Negishi　矢島照相館

27 矢島写真館 (歇業 / 私人住宅)
Yajima Photo House (Closed/Private-house)

這棟帶歐洲氛圍的建築從1918年起就一直是照相館。雖然店家已於2013年歇業，建築本身仍保持極佳狀態。外牆最早是鋪木板，不過顯然後來翻新時貼上磁磚。

With its European ambiance, this building has been used as a photo studio since 1918. Though the shop closed in 2013, the building itself has been preserved in good condition. The exterior was originally boarded with wood, but has apparently been refurbished in tiles.

我們前來取材時，很可惜正面雕刻已不復見。我利用在網路上找到的照片盡可能重現原貌。

Unfortunately, the front sculpture was missing when we came during our location hunting. I recreated it the best I could based on some photos I found online.

紅色屋頂和歐式簷口（牆面或屋頂上方平直的突出部分）使採折衷設計的建築更具多樣性。

The red roof and European-style cornice (a flat, protruding part above a wall or roof) make the already eclectic design of the building even more diverse.

這類雙層對稱的燈座過去常用於傳統日式店鋪和住宅（大部分為水平裝設）。復古的造型很得我心！

This kind of double, symmetrical light fixture was used a lot above entrances to Japanese shops and houses (most were installed horizontally). I like the retro look of it!

因氧化變綠、受風吹雨打而變黑的銅製招牌安裝在金屬浮腳上，在牆面投射出迷人的影子。

This copper sign, already green with oxidation and blackened by weather, is placed on metal spacers and casts some really attractive shadows onto the facade.

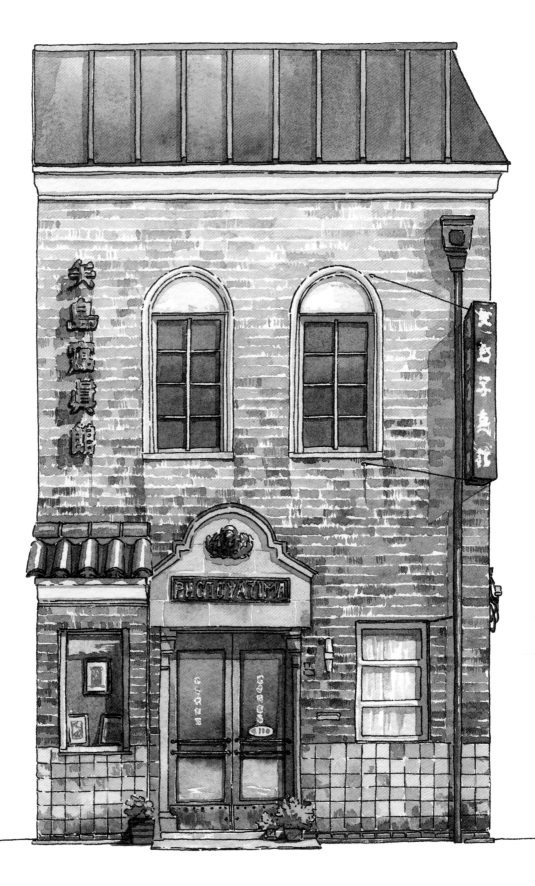

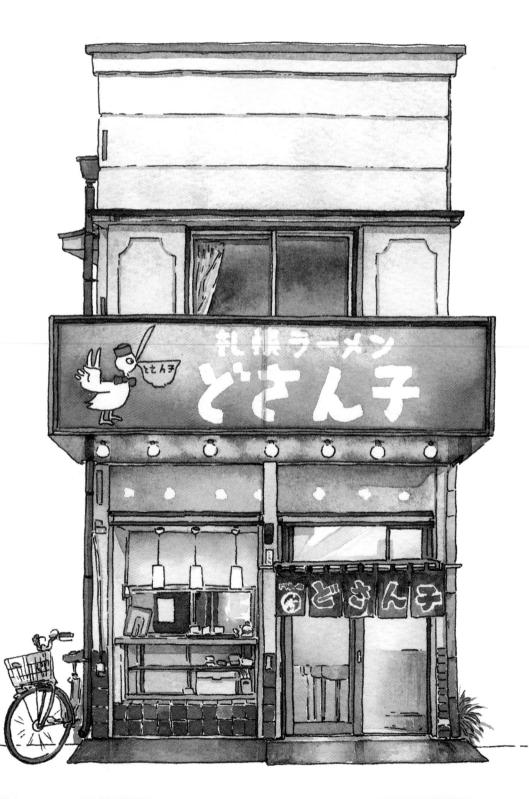

28

どさん子 千住一丁目店
Dosanko Senju-1chome

這間拉麵店位在東京東邊的北千住商店街上。我很享受描繪這家餐廳紅底白字的商標和招牌。文字部分使用留白膠繪製，我也試著重現傍晚招牌亮起時的溫暖感覺。

This is a ramen shop on a shopping street in Kita-senju, located on the east side of Tokyo. I had a lot of fun painting the main sign of this restaurant with its logo and white letters on a red background. I used masking fluid for the letters and tried to recreate the warm look the sign has when it is lit up in the evening.

這片暖簾上有店家的商標和名字，餐廳營業時會掛在門口，不過很容易取下，懸掛暖簾的支桿也能折疊收合，如此就能放下鐵捲門。

Bearing the shop logo and name, this *noren* is put out when the restaurant is open but can be easily taken down. The supports it is hung on fold as well, so the front rolling shutter can be brought down.

我很喜歡店面外的燈，營造出獨特的溫暖懷舊氣息，吸引人踏入餐廳。

I really like the lights of this storefront. They create a distinctly warm and inviting nostalgic atmosphere.

我很好奇這裡之前掛了什麼。也許是沿著街道行走時可以望見的招牌。

I wonder what was attached here. Probably a sign that could be read while walking down the shopping street.

外帶櫃檯下方的磁磚實際上真的就是這麼美麗的深紅色！

The tiles below the takeout counter really have this deep, beautiful red color!

內部請見下一頁 ▶

◀ 外觀請見前頁

28 どさん子 千住一丁目店 Dosanko Senju-1chome

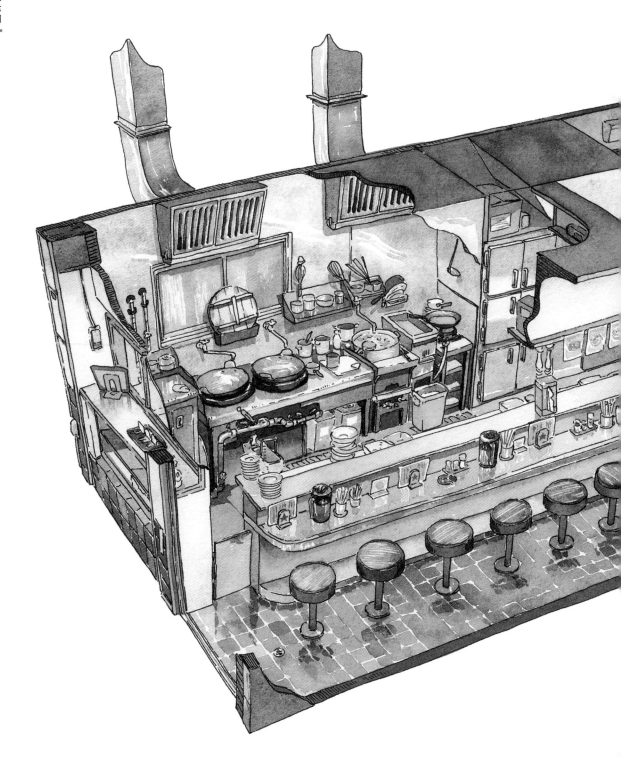

どさん子 千住一丁目店内部展開図
Dosanko Senju-1chome Inside View

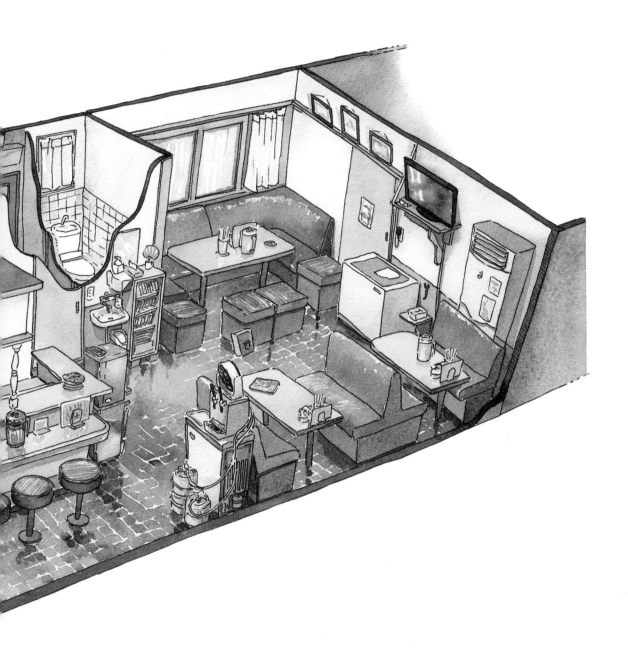

這家店的內部真的非常有都市拉麵店的感覺。我很喜歡這種溫馨氣氛，之前就曾畫過一次內部速寫。為了這張插圖，我在我們拍攝取材時更加注意內部細節，並且重新畫了一次。

The interior really has a city ramen shop feel to it. I like the cozy ambiance and have drawn a sketch of it once before. For this illustration, I checked the interior in more detail during our location hunt and painted it again from scratch.

②⑨ 鮒秋 Funaaki

鮒秋是北千住的佃煮專賣店，他們的自製蒲燒鰻也非常受歡迎。餐廳於1917年開業，不過木造建築或許比店家的歷史更悠久。不僅建築本身，入口的拉門、櫥窗，以及許多小巧精緻的手工細節，都讓店面顯得相當有趣。

Funaaki is a *tsukudani* shop in Kita-senju that is also renowned for its homemade grilled eel. The shop apparently opened in 1917, but the wooden building is probably even older. Not only the building itself, but the sliding doors at the entrance, the display windows, and a lot of smaller, carefully crafted details make for an interesting shop front.

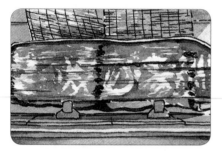

這塊充滿歷史氣息的巨大招牌上方雖然有銅製雨遮，但是招牌上的字幾乎已經看不見了。

This huge, historic sign has lost almost all its letters, even though it is protected from rain by copper covering on the top.

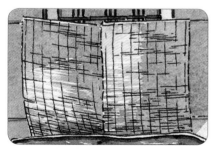

二樓的房間掛了兩塊竹簾，避免陽光直射。

The room on the second floor is protected from direct sunlight by two *sudare*, or reed screens.

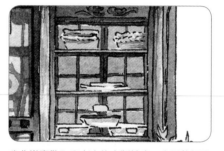

我非常喜歡入口右方的木製櫥窗。木頭飽經風霜，許多地方幾乎都變白了，不過反而更添個性。櫥窗內部也是雕刻精美的壁板。

I really like the wooden display window on the right side of the entrance. The wood is weathered, almost white in places, but this only adds it character. The insides of the display window also have beautifully carved wooden panel.

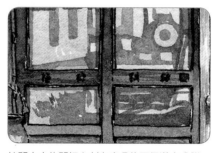

拉門中央的門把上刻有店名的兩個漢字「鮒」與「秋」。

The sliding doors have the two *kanji* characters of the shop's name carved into the middle bar.

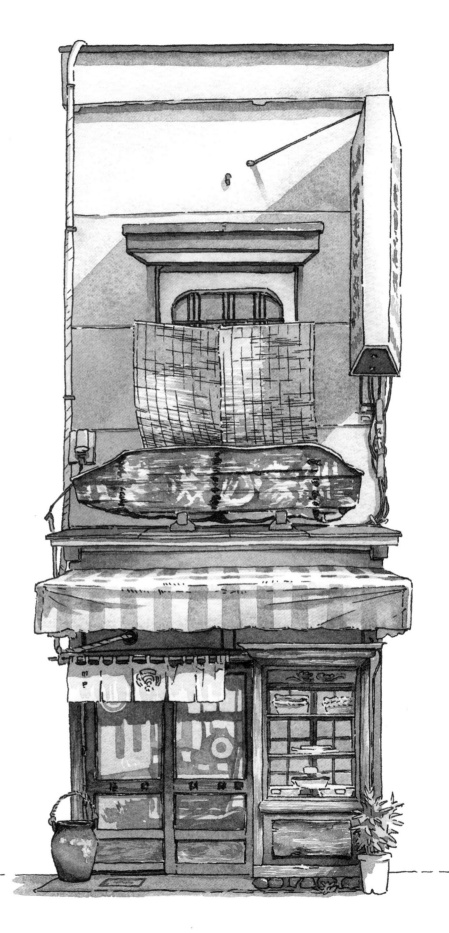

30

菊屋モータース
Kiku-ya Motors

這家早期販售汽車和機車的車行，現在成了腳踏車店，和道產子、鮒秋同樣位在北千住商店街。從店名「モータース」（motors）和挑高的天花板，可以想見這家店最早銷售汽車和機車的光景。

Kiku-ya Motors originally sold cars and motorbikes. Now it operates as a bicycle shop on Kita-senju Shopping Street along with Dosanko and Funaaki. The word "motors" in its name and the high ceilings suggest its original use.

我很喜歡這個復古的腳踏車商標。不過根據店家過去的背景，此招牌想必是後來才加上的。

I like the retro bicycle logo. The shop used to sell cars and motorbikes once, so this must have been added more recently.

店面兩側都裝上閃亮的金屬。我盡量描繪出金屬反射周遭景色和光線的樣子。

Both sides of the shopfront were covered in shiny metal. I tried to recreate as best I could the way the metal reflects the surrounding landscapes and light.

舊式的投幣打氣機，如果覺得輪胎沒氣了可以用來充氣。這裡 50 日圓硬幣可以讓你為輪胎充氣 80 秒。

An old style, coin-operated compressor you can use if your tires feel flat. Here, a ¥50 coin lets you fill your tires with air for 80 seconds.

與街道垂直裝設的招牌，讓走在商店街上的人們容易看見。

This sign is placed perpendicular to the street, making it easy for people walking down the shopping street to read it.

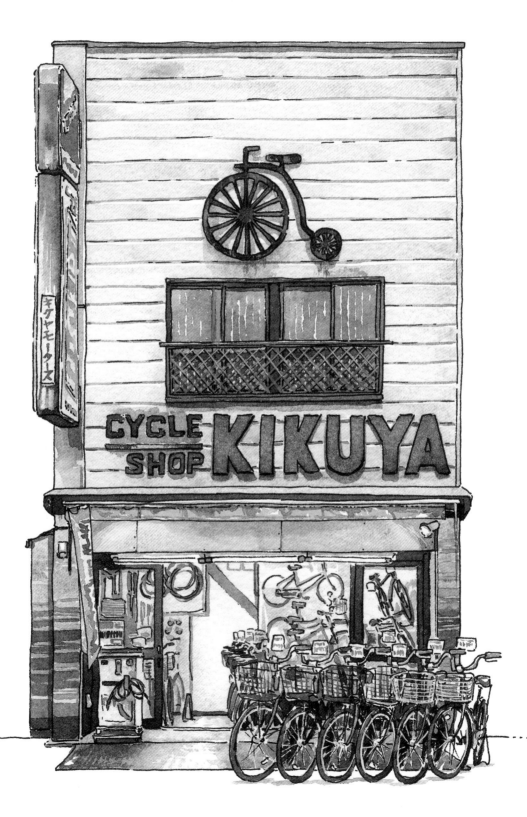

清澄白河　Kiyosumi-shirakawa　小島藥局

31 小島藥局
Kojima Pharmacy

店門口右邊的橘色大象是投幣式的兒童遊樂設施，叫做「佐藤象搖搖車」。佐藤象過去是藥局門口的尋常景色，但是現在已經看不太到了。我們到這裡取材時，真的投入硬幣讓搖搖車動起來。搖擺的佐藤象搭配響徹整個傍晚街區的主題歌，三個成年人（我與妻子香苗、編輯）全都童心大發地猛拍照，路過的人一定覺得這景象怪異極了。

The elephant figure to the right of the shop is a coin-operated moving children's play-thing called *Sato-Chan* Mover. Apparently, these used to be a common sight at drug stores, but you cannot find them these days. When we were location hunting, we tried actually putting in a coin to make it move. With its theme song playing loudly throughout town at dusk, *Sato-Chan* swaying, and the three adults (Matt, his wife Kana and the editor) innocently taking pictures, we must have been quite an odd sight to passers-by.

大招牌上的大字畫起來充滿樂趣。繪製這塊招牌時我使用了留白膠，讓落在彩色底色上的白色字樣顯得乾淨俐落。

A big sign with huge, fun-to-paint letters. Since the letters here are white on a colored background, I had to use the masking fluid to make them nice and clean.

牆上留著金屬欄杆。我猜之前可能裝了一塊垂直的大招牌。

A metal railing left on a wall. I'm guessing a big sign was attached here at some point.

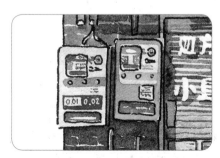

保險套的自動販賣機，上方有一個插座。

Vending machines selling contraceptives. There is a power outlet above them.

靠近一看，就會發現店面並不是磚造，而是貼滿紅色磁磚。

Closer inspection confirmed that the front of this shop is not made of brick, but red tile.

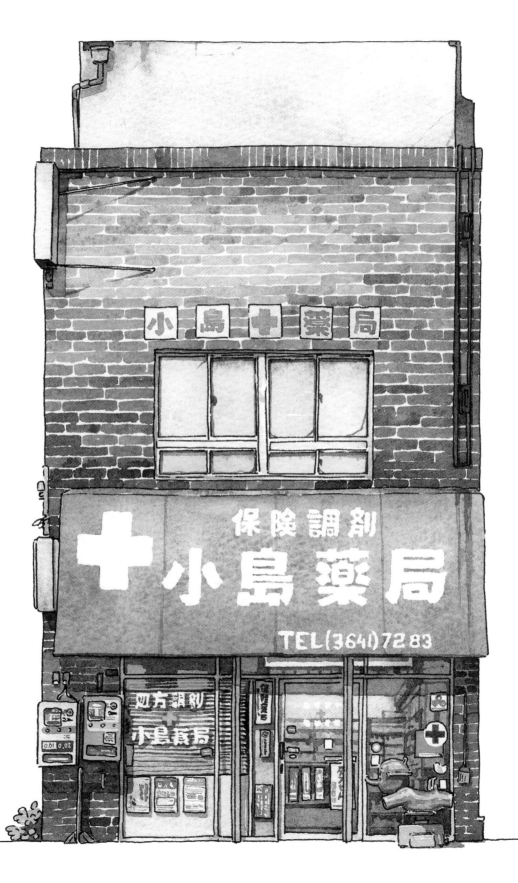

店鋪資訊
03
—

20 岡添耳鼻咽喉科眼科医院
Okazoe Otolaryngology&Ophthalmology

地址：台東区西浅草2-25-12
落成年份：1969 年
附註：門診的醫師在這一帶是出名
　　　的好醫生。

Address:
2 - 25 - 12 Nishi Asakusa, Taito-ku
Year built: 1969
Note: The examining physician has
an excellent reputation in the
neighborhood.

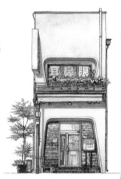

21 座ぶとんのこいずみ（已拆除）
Zabuton Koizumi (Demolished)

地址：台東区松が谷2-9-1
落成年份：1960 年代
附註：很可惜這棟建築已於2018
　　　年拆除。

Address:
2-9-1 Matsugatani, Taito-ku
Year built: 1960's
Note: Unfortunately, the building
was torn down in 2018.

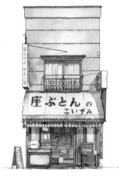

22 菊屋橋カメラコーナー
KIKUYABASHI Camera Corner

地址：台東区元浅草4-7-19
落成年份：1961 年
附註：這附近的一棟建築上有座大
　　　得驚人的廚師雕像。

Address: 4-7-19 Asakusa, Taito-ku
Year built: 1961
Note: A surprisingly big statue of a
chef atop a nearby building.

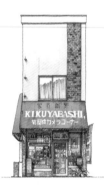

23 金桝屋ゴム（已拆除）
Kanemasu-ya Rubber Store (Demolished)

地址：台東区浅草橋3-20-13
落成年份：1951 年
附註：這家店現在已經遷址至墨田區，仍
　　　生意興隆地營業中！

Address: 3-20-13 Asakusabashi, Taito-ku
Year built: 1951
Note: This shop has moved to Tachikawa in
Sumida Ward and is doing well!

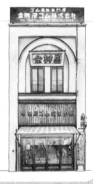

24 植村屋 Uemura-ya

地址：中央区月島3-3-3
落成年份：1956 年
附註：顧客很多，包括茶道老師
　　　和銀座公關小姐。

Address:
3-3-3 Tsukishima, Chuo-ku
Year built: 1956
Note: Many customers, including
tea ceremony masters and
Ginza hostesses.

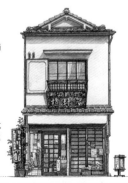

25 佃屋酒店 Tsukuda-ya Liquor Shop

地址：中央区佃1-2-8
落成年份：1912 ～ 26 年左右
附註：馬路對面有一口井，至今
　　　仍在使用中。

Address:
1-2-8 Tsukuda Chuo-ku
Year built: Between 1912 to 26
Note: The well on the opposite
side of the road is still in
use today.

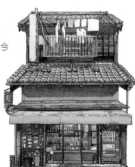

26 天安 Tenyasu

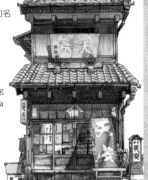

地址：中央区佃1-3-14
落成年份：1927 年
附註：這棟迷人的建築曾是知名
　　　漫畫的取材對象。

Address:
1-3-14 Tsukuda, Chuo-ku
Year built: 1927
Note: This charming building
　　　was used as a model for a
　　　famous manga.

27 矢島写真館（歇業／個人住宅）
Yajima Photo House (Closed/Private-house)

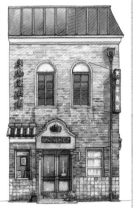

地址：台東区根岸4-1-25
落成年份：1918 年
附註：店鋪門面的現代磁磚是在
　　　1930 年加上的。

Address:
4-1-25 Negishi, Taito-ku
Year built: 1918
Note: Modern tiling on the
　　　shopfront was added in
　　　1930.

28 どさん子 千住一丁目店
Dosanko Senju-1Chome

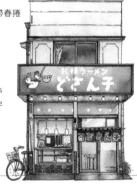

地址：足立区千住1-23-11
落成年份：1950 年左右？
附註：門口櫃檯提供客人外帶春捲
　　　和煎餃。

Address:
1-23-11 Senju, Adachi-ku
Year built: Around 1950?
Note: You can buy Spring Rolls
　　　and Fried Gyoza at the
　　　take-out counter.

29 鮒秋 Funaaki

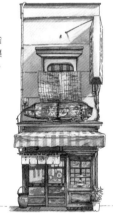

地址：足立区千住2-52
落成年份：1917 年以前
附註：年底限定販售的特產是「雀
　　　燒」（すずめ焼き），即裹
　　　滿特製醬汁燒烤的小鯽魚。

Address: 2-52 Senju, Adachi-ku
Year built: before 1917
Note: The year-end limited
　　　specialty is suzume-yaki,
　　　small crucian carp baked in
　　　sauce.

30 菊屋モータース Kiku-ya Motors

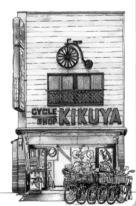

地址：足立区千住1-21-10
落成年份：1950 年代晚期
附註：店家商標上的大前輪腳
　　　踏車，是1870 年代開
　　　發的賽車專用車。

Address:
1-21-10 Senju, Adachi-ku
Year built: late 1950's
Note: The large wheel in the
　　　store's logo was developed
　　　in the 1870's as a wheel
　　　for racing.

31 小島薬局 Kojima Pharmacy

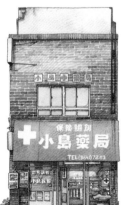

地址：江東区清澄3-3-30
落成年份：1928 年
附註：這是關東大地震後建造
　　　的「東京市營商用住宅」
　　　（東京市営店舗向住宅）
　　　之一。

Address:
3-3-30 Kiyosumi, Koto-ku
Year built: 1928
Note: One of the Tokyo municipal
　　　residences with storefronts
　　　built after the Great Kanto
　　　Earthquake.

赤羽
Akabane

32

池袋
Ikebukuro

35

33

早稻田
Waseda

新宿
Shinjuku

38

34

36

40

37

澀谷
Shibuya

39

品川
Shinagawa

41

32	丸全社	Maruzen-sya	088
33	寶美樓	Hōbiro	090
34	成文堂早稻田正門店		
	Seibun-do Front gate of Waseda Univ.		092
35	中島屋酒店	Nakashima-ya Liquor Shop	094
36	小林理容室（已拆除）		
	Kobayashi Barber Shop（Demolished）		096
37	精肉大田屋（已拆除）		
	Ōtaya Butcher Shop（Demolished）		098
38	多姆咖啡	café DOM	100
39	長屋咖啡	TENEMENT	102
40	費洛斯	FELLOWS	104
41	丸屋鞋店	Maru-ya Footwear Store	106

店鋪資訊04　　Shop Notes 04 ······················· 108

第4章
Chapter4

赤羽
Akabane

品川
Shinagawa

地區
Area

32 赤羽 Akabane 丸全社

丸全社 Maruzen-sya

丸全社是位在赤羽的一家鋼筆店，不僅販售鋼筆和文具，現在也因為獨創的刺繡而聲名遠播。透過店面窗戶就能看見的刺繡機器便是最佳證明。我很喜歡環繞店鋪正面和側面屋簷的塑膠布棚頂。

Maruzen-sya is a fountain pen shop in Akabane. Not only do they sell fountain pens and stationery, but are currently renowned for their original embroidering. The embroidery machine visible through the store window tells of this. I like the fabric roof that spans the front and entire side of the shop.

老舊的招牌中間是店名，上面還有一些老牌鋼筆的商標。我很慶幸即使店面多年來經過數次整修，這塊招牌仍被保留下來！

The old sign with the shop name in the middle has some really old fountain pen brand logos in it. I'm very happy that somehow it survived all the remodeling the shop went through over the years.

我很驚訝在文具店前會看到高爾夫球具袋。在皮製高爾夫球具袋這類最棘手的材質上繡出色彩繽紛的圖樣，是這家店的拿手絕活。

I was surprised to see golf bags in front of this stationery store. Embroidering colorful patterns onto even the most difficult things, like leather golf bags, is this shop's specialty.

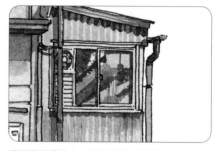

這個區塊是後來加蓋在這棟建築物上的，內部是廚房空間。

This part, added later to the building, contains the kitchen.

傍晚時會亮起 LED 招牌。

The LED sign is turned on in the evening.

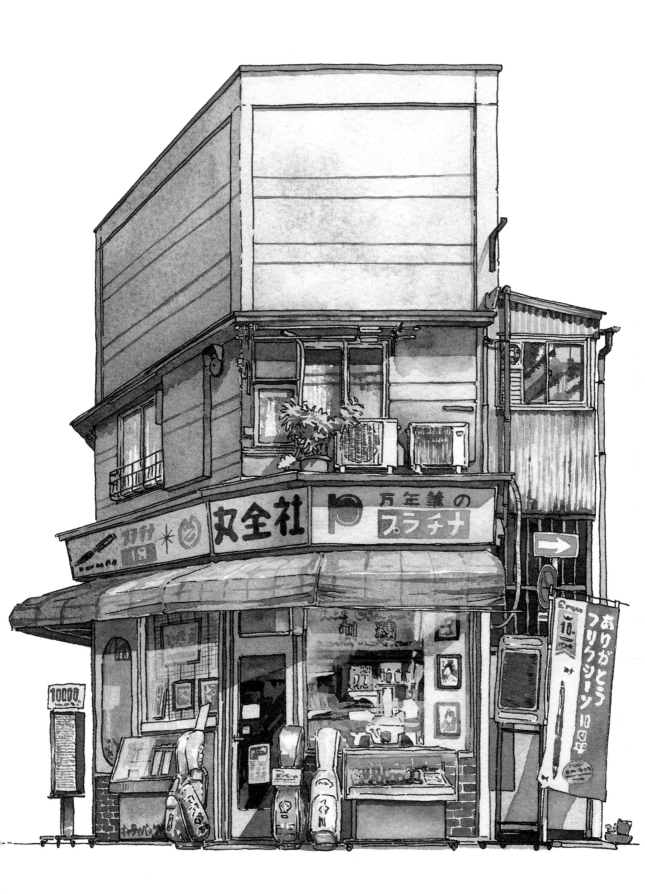

33 宝美楼 Hōbiro

這家座落在早稻田大學城的中式餐廳，自1948 年開業以來，一直廣受當地居民和學生喜愛。這棟建築原本和隔壁的另一棟建築相連，因此屋頂才會被怪異地切成一半。

Hōbiro is a Chinese restaurant situated in the university town of Waseda. It has been loved by locals and students since its opening in 1948. Originally, this building was connected to another shop next door (the strangely cut roof is a remnant of this).

我非常喜歡觀察屋頂上的小細節。據我所知，這個叫作「鴟尾」，不僅是裝飾，傳說還有避火的作用。鴟尾令我想起兒童漫畫角色「阿斯特」（Astérix）頭盔上的小翅膀。

I really like these small details on the roof top. From what I learned, they are called *shibi*, and not only do they serve as decor, but are supposed to ward off fire. They remind me of the small wings on a helmet of a character from a kid's comic called Astérix.

深紅色的磁磚和小巧的金屬圍欄，令整家店更吸引目光。

The deep red tiles and small metal fence make the shop even more eye-catching.

金光閃閃的屋頂使這家餐廳比街上其他店家更搶眼。

The glittering golden roof makes this restaurant really stand out among other buildings on this street.

隔壁現在蓋起一棟新的建築物，但是我記得曾在別的中式餐廳旁看過倒放的啤酒箱，因此決定加入畫面。

A new, separate building has been built next door, but I remembered a scene of overturned beer cases I saw once next to another Chinese restaurant and decided to add them here.

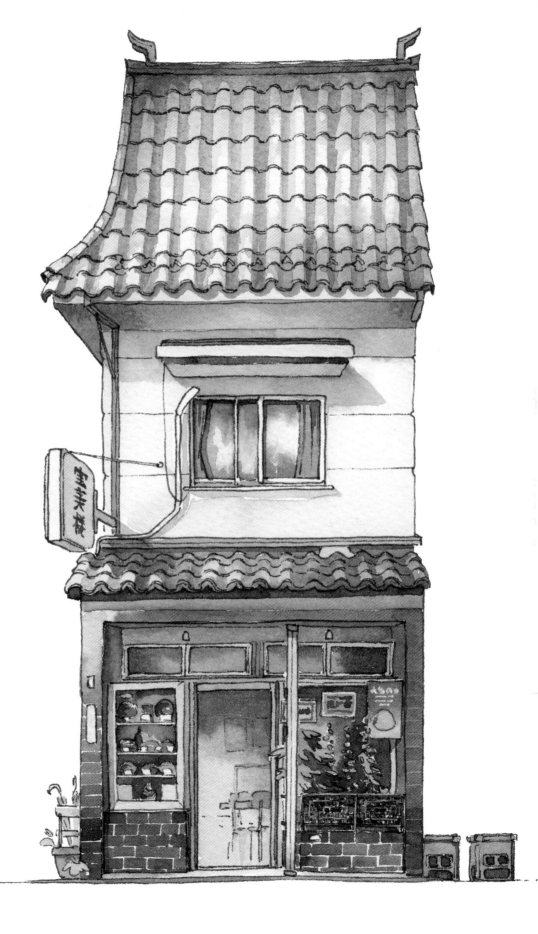

3 4

早稻田 Waseda | 成文堂早稻田正門店

成文堂 早稻田正門店
Seibun-do Front gate of Waseda Univ.

這間書店位在知名的早稻田大學附近，客群瞄準法學院學生，垂掛的巨大帆布條幾乎蓋住整家店的正面，還會隨著學年行事曆更換。這家店的存在感無與倫比，可惜我們不能進行店內的拍攝取材，僅獲得店外的插畫授權。

Located near the famous Waseda University, this bookstore aimed at law students, has enormous banners covering the front of the shop, changing in tune to the school calendar. This shop's powerful presence is incredible. Unfortunately, we were not allowed to take pictures inside.

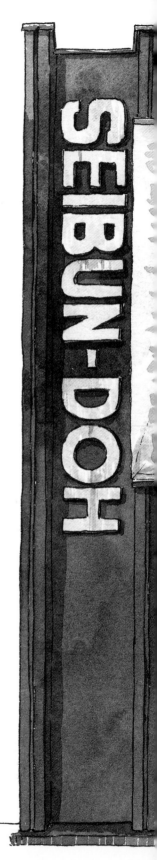

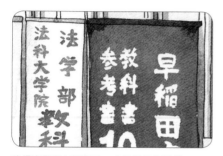

我很喜歡學年剛開始、布條掛起的時候。

I really liked when the school year started and the banners went up.

黑底上的白色立體字，搶眼的招牌設計充滿現代感，遠遠就能一眼望見。畫起來也很過癮。

With three-dimensional white letters on black, this sign has an eye-catching modern design and can be seen from quite a distance. It was also really fun to paint.

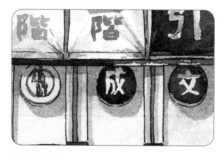

我也很喜歡入口上方造型復古的圓形招牌。最左邊的圓圈上繪有書店的商標──正義女神※。

※ 特米絲（Themis）是掌管法律的女神。這家店則以她的拉丁名字──Justitia──稱呼她。

I also like the round, retro-looking letters above the entrance. The leftmost circle has the shop's logo Lady Justice* painted on it.
*The goddess of law, Themis. In this shop, they call her by the Latin name "Justitia".

架上放滿各種法學院學生資格考的傳單。

Stands with tons of leaflets advertising various qualification exams for law students.

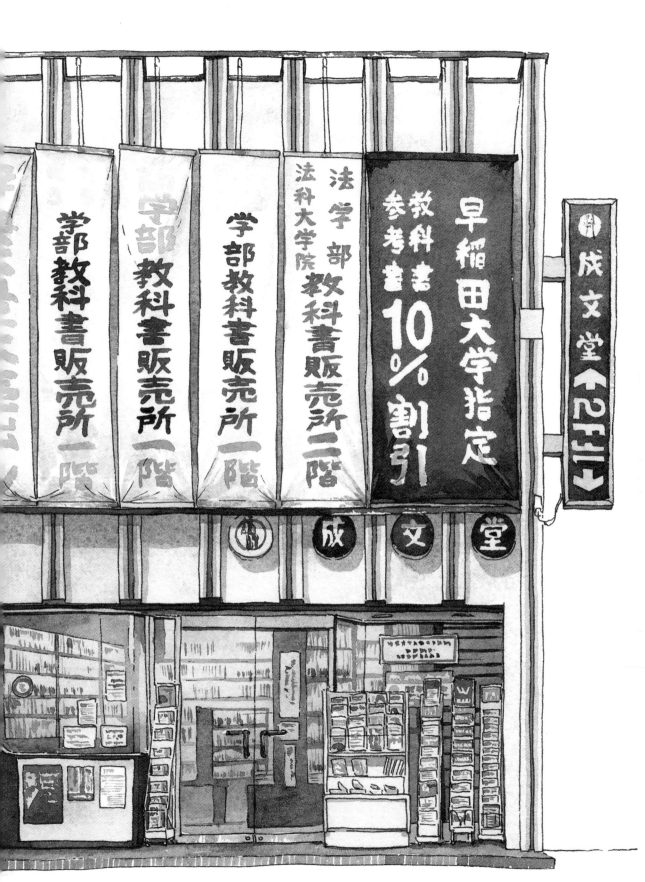

35

護國寺 Gokokuji　中島屋酒店

中島屋酒店
Nakashima-ya Liquor Shop

中島屋酒店是酒類專賣店，位在綠意盎然的目白台一帶。最早是三棟連在一起的建築，分別有三家商店，不過如今只剩下這一棟屹立不搖，兩側的建築已被夷為停車場。充滿摩登感的半圓山形牆使這家店更醒目。

Nakashima-ya is a liquor shop in the lush green Mejirodai area. There were originally three connected buildings here which housed three separate stores, but only one of them, flanked by parking lots, still stands. The round, modern looking top pediment makes this store really stand out.

我很喜歡這家店漆成粉紅色的外牆。不知道油漆底下的牆面是否鍍了一層銅呢？

I like that the shop's facade is painted pink. I wonder if the wall is clad in copper underneath the paint.

販售無酒精和酒精飲料的自動販賣機幾乎遮住拉門。

The vending machines selling soft drinks and alcohol obscure most of the sliding doors.

較老舊的日式建築經常使用塑膠浪板屋頂為二樓陽台或停車位遮頂。我喜歡浪板半透明的樣子，也喜歡穿透浪板形成的繽紛彩色光線。

Corrugated plastic roofs are often used on older Japanese buildings as protection for second floor balconies or parking spots. I like how they are half-translucent and let colorful light through.

似乎是店家用來送貨的 Honda Cub。我喜歡 Cub 摩托車的復古造型，尤其是像這台一樣的舊款。

A Honda Cub appears to be used for deliveries. I like the retro look of the Cub, especially the older models like this one.

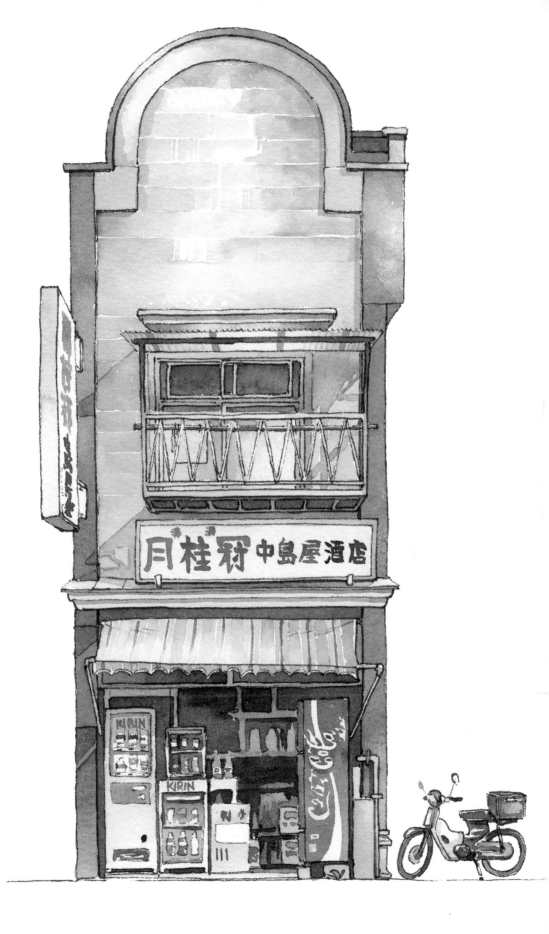

市谷 Ichigaya 小林理容室

3 6

コバヤシ理容室（已拆除）
Kobayashi Barber Shop (Demolished)

這家繽紛的理容店過去位在市谷附近，不過已經歇業拆除了。之前因為工作緣故，我曾經住在這附近，在理容店仍營業時畫下了這幅插畫。收錄這家店之前，我們很想和前任店主聯絡，無奈問遍街坊鄰居，仍無法得到半點消息。

Located near Ichigaya, this colorful barber shop has already been closed and torn down. I used to live near it due to my previous job, and painted this illustration whilst it was still in business. We would have liked to have gotten in touch with the previous owner before featuring the shop, but alas were unable to get any information, despite going as far as asking around the neighborhood.

店家在招牌和商標上用了許多不同字體和風格，令原本在設計上就充滿多元建築風格的店面更加混亂。

Lots of different fonts and styles are used in the many logos. It adds to the already quite eclectic design of the shop front.

我畫了掛在曬衣架上晾乾的毛巾。我非常喜歡這類充滿生活感的小細節。

I painted the towels hung to dry on a plastic hanger. I really like details like this.

我試著強調整家店的配色，使用柔和的粉紅色和土耳其藍讓插畫顯得更生動。

I tried to emphasize the color scheme of the shop and make the illustration look more alive by using subtle pinks and turquoise.

傳統的日式波浪屋頂瓦片和店面外觀的摩登設計之間形成鮮明對比，令店面充滿魅力又獨具特色。

The contrast between the traditionally Japanese *kawara* roofing tiles and the modern design of the exterior makes this storefront captivating and original.

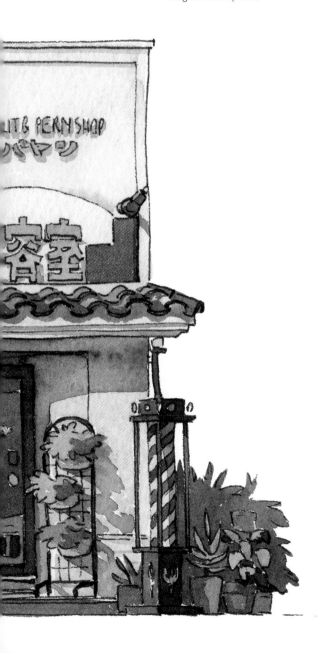

37　麴町 Kojimachi　精肉大田屋

精肉 大田屋（已拆除）
Ōtaya Butcher Shop (Demolished)

精肉大田屋座落在東京都心繁忙的商業區。這家店過去非常受歡迎，即使已歇業，熟客仍常常向店主說「以後要上哪去買肉呀！」。這家獨特的店最初漆成竹綠色，曾是這一帶居民仰賴的重要基石與象徵。

Otaya Butcher Shop is located in a busy business district in the heart of Tokyo. As it was really popular, even after it closed down, the regulars would keep asking the owner where else they should buy meat. This unique shop, originally painted bamboo green, was an important cornerstone of their lives and a symbol of this town.

整家店漆成明亮藍色，在鋼筋水泥建築林立的麴町特別顯眼。（根據店主，最初是漆成竹綠色，但是經過歲月洗禮，轉為偏藍的綠色了。）

The bright blue color this whole shop was painted really stood out amongst all the metal and concrete office buildings in the Kojimachi area (according to the owner, it had been bamboo green when it was first painted, but turned a bluish green with the passage of time).

以日文的「肉」字為基礎而設計的商標。充滿現代感的設計和整間店非常搭調。

A stylized logo based on the Japanese character for meat「肉」. The modern design fits well with the rest of the shop.

我好喜歡這些磁磚，每一片顏色都不盡相同，以不同方式反射光線，很難不被吸引目光！

I just love the ceramic tiles, all of them a slightly different color and reflecting light in different ways for a constantly eye-catching effect!

我非常喜歡觀賞寫在店面或拉門上的金色字樣（這家店的字其實是黃色，但是在光線照射下如金色般閃亮）。我情不自禁地用了少許金色壓克力顏料描繪此處細節。用水彩重現這類對比和明亮感並不容易。

I really love these gold color letters I sometimes see painted on storefronts or glass sliding doors (the lettering on this shop was actually yellow, but shone like gold in the light). I could not resist using a bit of gold acrylic paint for this detail. Recreating such contrast and brilliance in watercolors is difficult.

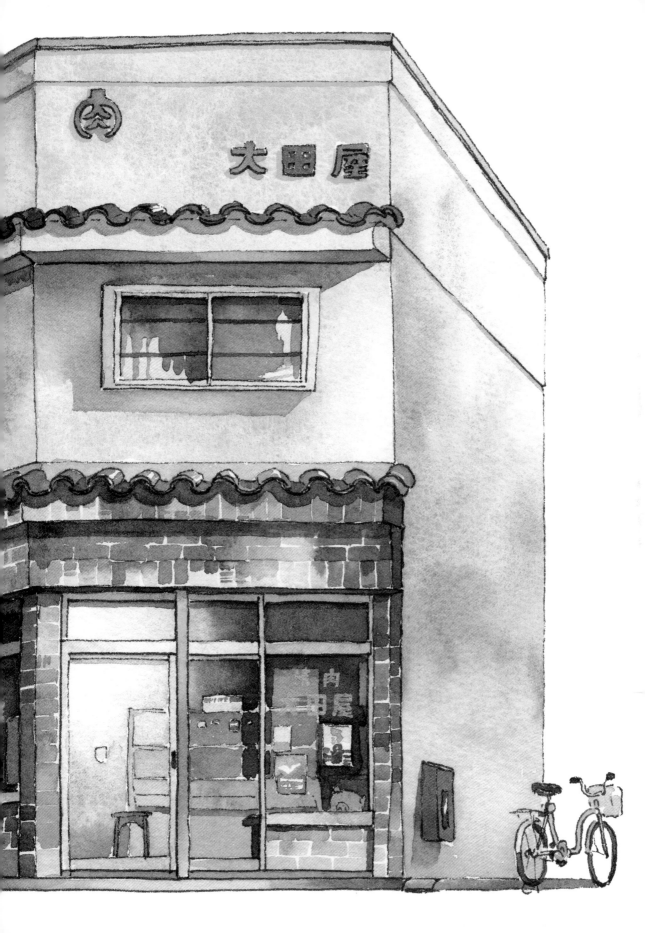

新宿 Shinjuku　多姆咖啡

38 カフェテラス DOM
café DOM

這家店的名字起初很令我好奇，因為在我的母語波蘭文中，「DOM」有「房屋」或「家庭」的意思。我不知道在日文中有什麼含意。唯一能想到的關聯，就是電視動畫〈機動戰士鋼彈〉中的人型機器人代號。不過我仍懷疑店名其實來自波蘭文。

The name of this shop intrigued me at first because it means "house" or "home" in my native Polish. I don't know the significance of it in Japanese. The only thing I could find is a reference to a humanoid robot appearing in the Gundam animated TV series. I doubt the name comes from Polish.

店主手作的木製招牌和紅色信箱。

The owner's handmade wooden sign and red post box.

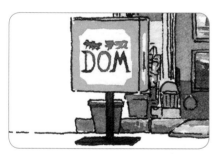

招牌燈箱上打出店名「DOM」。（後來經過確認，店名是來自法國的香甜酒——Bénédictine D.O.M。據說曾經擔任某財團會員制俱樂部吧台的店主，常常請客人飲用這款酒。）

A light-up sign with the café's name "DOM". (We later confirmed that the origin of the shop's name comes from Bénédictine D.O.M, a French liqueur often served to customers by the owner, who used to be in charge of the bar at a certain financial conglomerate members' club!)

冷氣主機安裝在割開的遮陽棚裡，是這家店吸引我目光的第一個部分。這並不是我看過解決冷氣主機安裝難題最有型的方式，不過確實為這間店增添個性。

The air-conditioning unit installed in the cut-out marquee was the first thing about this shop that caught my eye. It's not the most stylish solution to the problem of placing an air conditioning unit that I have seen, but it certainly gives the shop some character.

厚實的綠色大門，上面鑲著鐵製的堅固把手。門上的玻璃窗透出溫暖的室內景色，吸引著過路行人入內。

These sturdy green doors have solid iron handles. The warm interior of the shop seen through the glass panes invites passers-by.

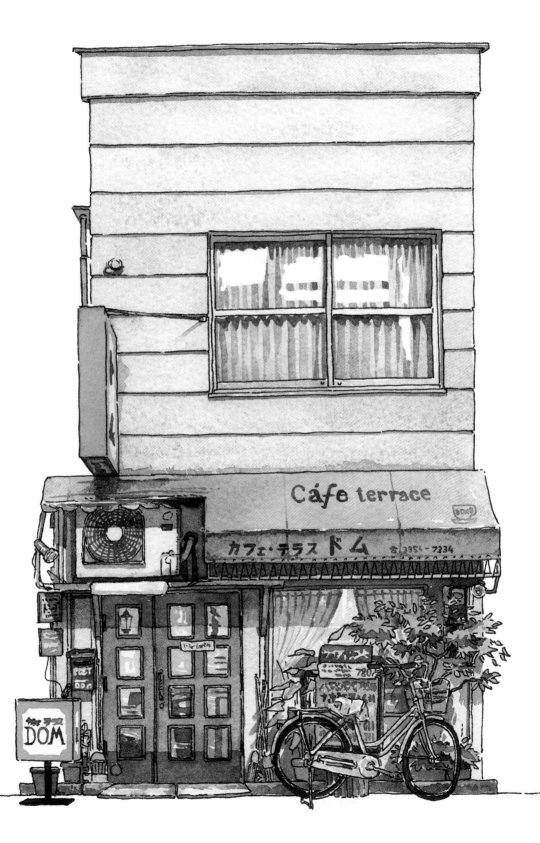

39 テネメント TENEMENT

惠比壽 Ebisu　長屋咖啡

這家重新改裝的老民宅咖啡廳座落在位於澀谷南邊的惠比壽地區。附近一帶有非常多老屋改建的店家。雖然維持日本味十足的外觀，內部卻翻新為現代風格。

TENEMENT is a café built in a refurbished traditional style house in an area south of Shibuya called Ebisu. This area has many such shops using remodeled old buildings. Although the exterior maintains its very Japanese décor, the interior has been renovated into a modern style.

這家店其實是整排連棟式建築的一部分，因此二樓有加裝翼狀擋板，這樣較容易區別出每家店的範圍。

Because this shop is actually a part of a row of buildings, it has wing-like partitions on the second story to make it easy to tell where one store ends and the next begins.

下緣稍微收起的捲簾，用在這類老房子上真的好看極了！

The partially rolled-up *sudare* blinds just look great used on an old building like this!

傍晚時，店鋪會點上整面明亮的燈光。

All parts of this shop's front light up brightly in the evening!

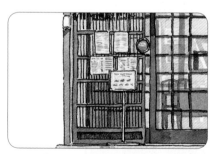

我認為這副拉門應該是從這棟建築（或是另一棟建築）的其他部分移過來重新利用的。

I think these sliding doors were brought over from a different part of this building (or from a completely different building), and are being reused.

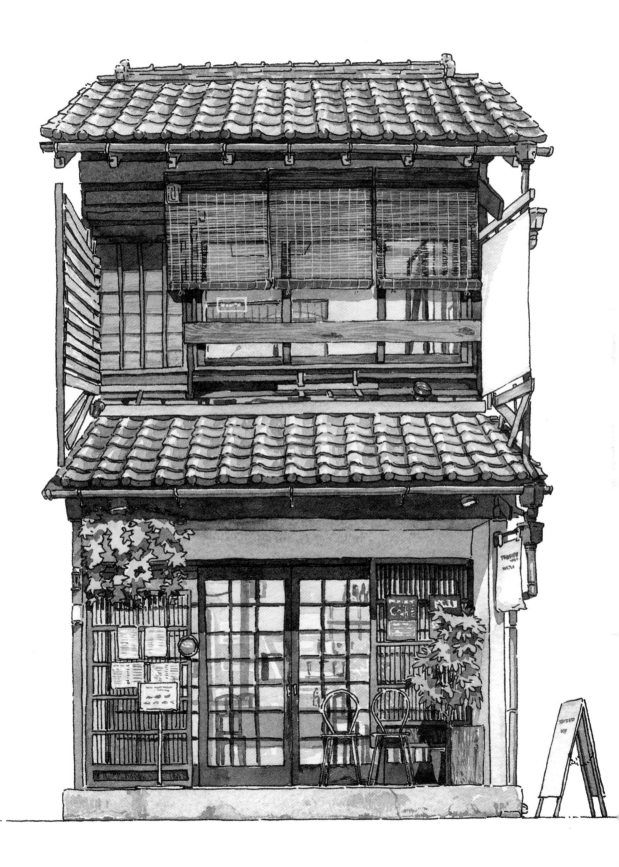

40 フェローズ FELLOWS

表参道　Omote-sando　費洛斯

這間漢堡店位在集結了東京所有大型服裝店的表參道。由於極受歡迎，店門口永遠大排長龍。漢堡店於 2011 年開業，建築物本身則落成於 1980 年代，雖然沒有悠久的歷史，建築物外觀仍非常可愛，因此我決定畫成插畫在此特別介紹。

Fellows is a hamburger shop in Omete-sando, where all the big apparel shops in Tokyo come together. And since it is popular, there are always lines in front. The shop opened in 2011 and the building itself was built in the 1980s, but despite its lack of a long history, it has a very cute exterior, which is why I decided to feature it here.

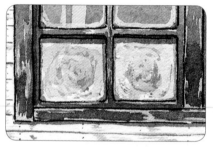

這扇窗戶的玻璃被隨意塗上白漆，是保護店內客人隱私的好辦法，同時使得窗戶帶點獨特（而且有點神祕）又粗獷的感覺，我很喜歡。

I like how part of the glass in these windows is haphazardly painted white to protect the privacy of the people sitting inside. It gives the windows a unique (and slightly weird) rustic feel.

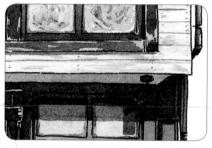

我不知道是否為特意營造，不過我很喜歡店面上方斑駁的油漆效果，與一樓漆成綠色的鋼材牆面之間形成對比。

I don't know if it was intentional, but I like the weathered paint effect on the top part of the shop front and the way it contrasts with the bare green painted metal of the ground floor.

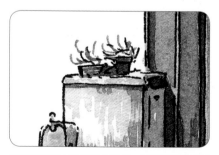

老舊的冰箱上放著幾個盆栽。我猜冰箱應該已經不能用了。

There are some plants standing on an old refrigerator. I don't think the refrigerator works anymore.

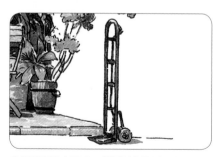

我們即將拍完照時，貨運送來飲料到店裡。我決定在畫面中加入這個破舊的推車。

Just when we were about to finish our small photo session, a delivery of drinks came to the store. I decided to put the beaten-up delivery cart in the illustration.

41 丸屋履物店
Maru-ya Footwear Store

丸屋履物店創立於1865年，販售傳統日式鞋類，包括「下駄」、「草履」、「雪駄」。整棟建築深具魅力，我特別喜歡這家店的菸草櫃，這正是東京還允許在公共場合抽煙的時代遺物。

Founded in 1865, Maru-ya Footwear Store sells traditional Japanese footwear, including *geta*, *zori*, and *seta*. While the overall building itself is very charming, I especially like the cigarette vendor in this shop. This is a relic of when smoking in public was still permitted in Tokyo.

「雨戶」（遮雨的拉門式窗板）飽經風霜的木頭質地美極了。中央的雨戶還留有些許顏色，也許是晴天時常收納在兩側「戶袋」（收納雨戶的空間）的緣故吧。

The weathered wood texture on the storm shutters is simply beautiful. The central shutters have more color left, probably because they are often stowed away on the sides.

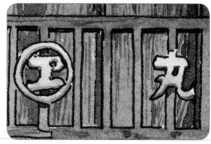

塗上金漆的木製文字招牌。文字招牌直接裝設在陽台欄杆上的方式其實並不常見。

A wooden sign painted gold. The way it is mounted directly on the balcony balustrade is somewhat unusual.

巨大的折疊式遮雨棚在店內投下漂亮的陰影，棚子本身經過多年使用，稍微褪色了。

The huge, foldable roof casts a lovely shadow onto the shop interior, its color slightly faded from years of use.

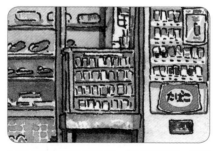

這是本系列最後完成的一幅店鋪插畫。非常開心終於能夠畫一家有菸草櫃櫥窗的店！（我不抽菸，而且我本身也反菸，但是菸草櫃是老式日本商家的特有元素之一，所以無論如何我都想畫一次看看。）

This was the last shop I painted in this series. I was very excited to finally feature one with a cigarette window. (I don't smoke and am personally against it, but these cigarette vendors are a very characteristic element of old Japanese stores.)

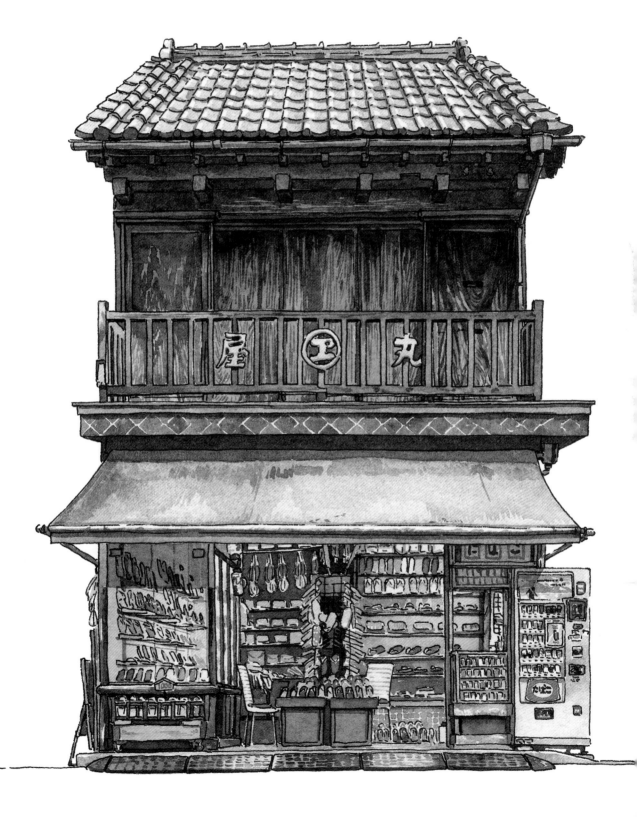

店鋪資訊
04

3|2 丸全社 Maruzen-sya

地址：北区赤羽1-35-1
落成年份：1960 年
附註：這家店最初為開放式鋼筆
　　　櫃攤位，剛開業時沒有正
　　　門也沒有櫥窗。

Address:
1-35-1 Akabane Kita-ku
Year built: 1960
Note: This shop operated as
a open style fountain
pen vendor with no
front doors nor shop
windows when it
opened.

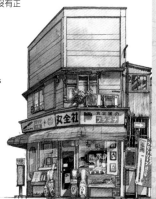

3|3 宝美楼 Hōbiro

地址：新宿区西早稲田3-1-6
落成年份：1948 年
附註：夫婦兩人經營的家庭式店
　　　面。他們目前很煩惱沒有
　　　人接手經營餐廳。

Address:
3-1-6 Nishi-Waseda, Shinjuku-ku
Year built: 1948
Note: A mom-and-pop shop.
They worry that there
currently in no one to take
over the business.

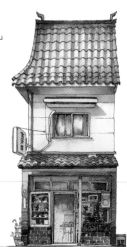

3|4 成文堂 早稲田正門店
Seibun-do Front gate of Waseda Univ.

地址：新宿区西早稲田1-9-38
落成年份：1940 ～ 50 年代
附註：早稲田大學的學生在這裡買教科書
　　　和參考書可享九折優惠。

Address: 1-9-38 Nishi-Waseda, Shinjuku-ku
Year built: 1940 to 50's
Note: Waseda students get 10% discount on
textbooks and reference books.

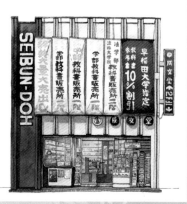

3|5 中島屋酒店
Nakashima-ya Liquor Shop

地址：文京区目白台3-16-240
落成年份：1936 年左右
附註：附近的東京聖瑪麗大教
　　　堂是建築愛好者的必訪
　　　景點。

Address:
3-16-240 Mejirodai, Bunkyo-ku
Year built: Around 1936
Note: The nearby St. Mary's
Cathedral, Tokyo, is a
must-see for architecture
lovers.

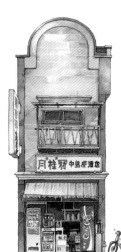

3 6 コバヤシ理容室 (已拆除)
Kobayashi Barber Shop (Demolished)

地址：千代田区三番町14
落成年份：不明
附註：這家店已經拆除。如果任何人知道店主的消息，請告訴我！

Address:
14 Sanbancho, Chiyoda-ku
Year built: Unknown
Note: The shop has already been torn down. If anyone knows what has become of the shopkeeper, let me know!

3 7 精肉 大田屋 (已拆除)
Ōtaya Butcher Shop (Demolished)

地址：千代田区麹町2-3
落成年份：1960 年左右
附註：由於店面外牆漆成藍綠色，後來街坊鄰居稱這家店為「綠屋」（the Greenhouse）。

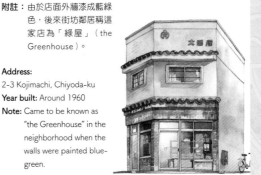

Address:
2-3 Kojimachi, Chiyoda-ku
Year built: Around 1960
Note: Came to be known as "the Greenhouse" in the neighborhood when the walls were painted blue-green.

3 8 カフェテラス DOM
café DOM

地址：新宿区新宿1-30-7
落成年份：1960 年代晚期
附註：店主也非常喜歡插畫呢！

Address:
1-30-7 Shinjuku, Shinjuku-ku
Year built: Late 1960s
Note: The owner is fond of illustrations as well!

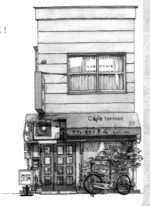

3 9 テネメント TENEMENT

地址：渋谷区恵比寿2-39-4
落成年份：1920 年代？
附註：由於店家為唱片公司所有，店內的座椅皆為鋼琴椅。

Address:
2-39-4 Ebisu, Shibuya-ku
Year built: 1920s?
Note: Since the store is owned by a record label, the chairs are piano chairs.

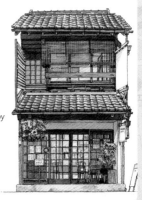

4 0 フェローズ FELLOWS

地址：港区北青山3-8-11
落成年份：1980 年代
附註：多汁的漢堡肉排是炭火炙燒的正統風味。

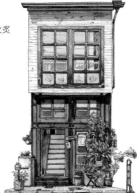

Address:
3-8-11 Aoyama, Minato-ku
Year built: 1980s
Note: The juicy patty is grilled over a charcoal flame for authenticity.

4 1 丸屋履物店
Maru-ya Footwear Store

地址：品川区北品川2-3-7
落成年份：1910 年代
附註：店家網站每天都會更新「每日一鞋」專欄，介紹各種樣式的鞋款。

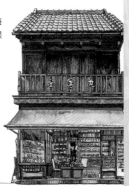

Address:
2-3-7 Kitashinagawa Shinagawa-ku
Year built: 1910's
Note: The website updates every day with a "Shoe of the Day" column introducing footwear.

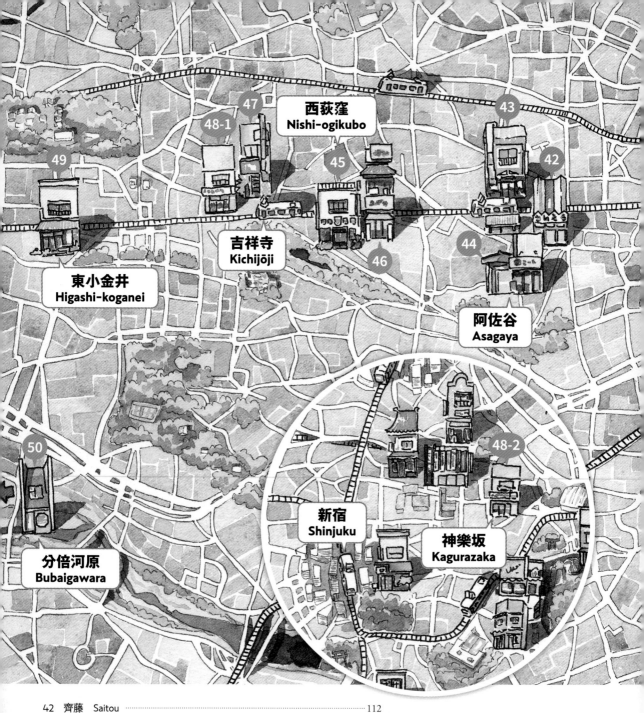

42 齊藤　Saitou ·········· 112
43 鳥久　Torikyu ·········· 114
44 肉醬屋　Miito-ya ·········· 116
45 酒藏千鳥　Sakagura Chidori ·········· 118
　　一内部展開圖　Inside View
46 卜派　Popeye ·········· 122
47 庫庫廚房　Kitchen KUKU ·········· 124
48 石村輪業＋神樂坂自行車　Ishimura Cycle＋Kagurazaka Cycle ·········· 126
49 不倒翁堂（歇業／私人住宅）　Daruma-do（Closed/Private-house）·········· 128
50 陽光理容室　Sunny Barber Shop ·········· 130

店鋪資訊05　Shop Notes 05 ·········· 132

第5章

Chapter5

中央線沿線地區

Around the Chuo Line

Area

阿佐谷　Asagaya　齊藤

4 2 さいとう Saitou

本店位在阿佐谷，以前是一家麵包店。建築物上半部充滿現代風格和設計感，令我驚艷不已。因為座落在拱廊商店街內，店鋪上方其實有棚頂覆蓋，不過我決定不畫出來，以好好展示外觀牆面。

Saitou in Asagaya was once a bakery. I was really surprised by this storefront's upper part and how modern and stylish it is. This shop is a part of a shopping arcade so it is covered by a roof, but I decided not to paint it here so I could showcase the façade.

店鋪主招牌的字體也極具現代化風格。即使每個字的顏色都不一樣，放在一起的整體效果卻相當好。文字周圍繞上霓虹燈，而且每一個字都有各自的燈。

The font used for the shop's main sign is also very stylized and modern. Even though all the letters are of different colors, it works together well as a whole. The area around the letters is surrounded in neon, and each and every letter has lights on it.

和牆面垂直的招牌，朝向商店街。

A sign perpendicular to the facade, facing the shopping street.

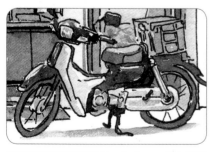

經典送貨專用摩托車 Honda Super Cub 的新型車款。雖然我自己偏好舊款，還是決定將這台摩托車放在畫面中。

Honda Super Cub, a newer model of the iconic delivery bike. I decided to paint it here even though I personally like the older models better!

影印紙上寫著帶點祕教感的怪異符號，就貼在正門窗戶上。我們詢問店主符號的意義，但是經過困難冗長的解釋，我們依舊一頭霧水。

A weird occult-like sign written on a piece of printer paper and stuck to the front window. We asked the owner what it meant but after difficult and long-winded explanation, we were none the wiser.

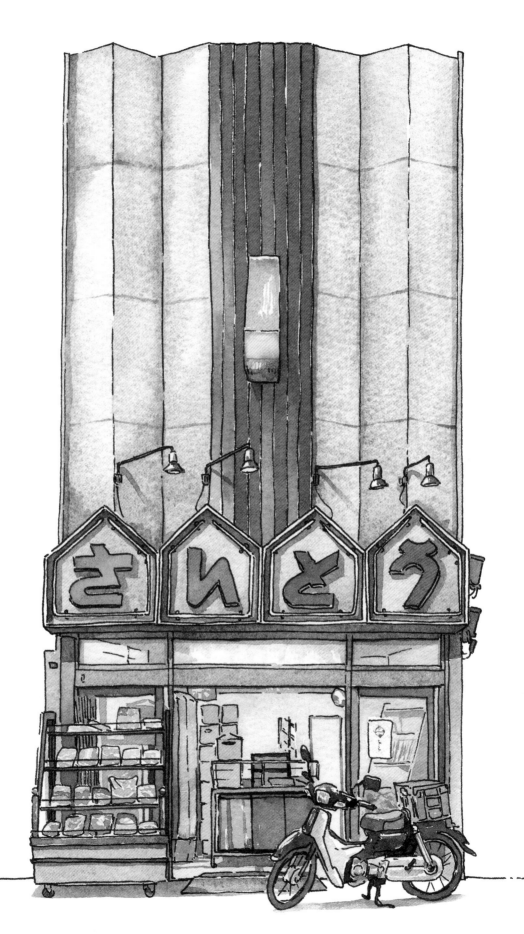

43 鳥久 Torikyu

鳥久是阿佐谷非常熱門的烤雞肉串餐廳。粗壯的金屬排煙管一路延伸至屋頂，設置在店鋪正面的原因很可能單純是因為沒別的地方可放了。我很喜歡排煙管在建築上別具一格的樣子。能在這本書中畫這麼多排煙管和其他金屬部分，真是太享受了！

Torikyu is a popular *yakitori* shop in Asagaya. The thick metal duct extending to the roof was probably placed in the front of the shop because there was simply nowhere else to put it. I really like the way it stands out on the building. Painting the many ducts and other metallic parts for this book was a delight!

深邃的藍綠色磁磚在陽光下閃耀著美麗的光芒。尤其每一片磁磚的顏色略有不同，彷彿擁有生命一般。

The deep blue-green tiles shine beautifully in the sunlight. In particular, the way the colors differ slightly from tile to tile gives them an almost organic feel.

巨大的手寫漢字，上面寫著「酒」和意為雞肉的「鳥」。

Huge, hand written *kanji* that say "*sake*" and "chicken".

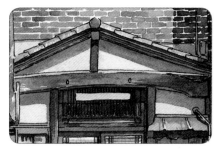

這根橫樑保留了木材彎曲歪斜的原始樣貌，想必建造時費了不少功夫調整支柱和其他周圍的元素。即使大費周章，木匠一定很希望可以保留這根獨特的樑吧。多美的木工作品啊！

This beam leaves the warp of the wood in place, meaning they probably had to adjust the pillars and other surrounding elements to use it. Despite the trouble, the carpenter must have really wanted to use this particular beam. What a beautiful piece of woodwork!

我喜歡門板木頭顏色的變化，經年累月的使用轉成灰色，且越靠近地面的部分又變成綠色。

I like how the wood of the doors changes colors, becoming grayer and greener the closer it gets to the ground.

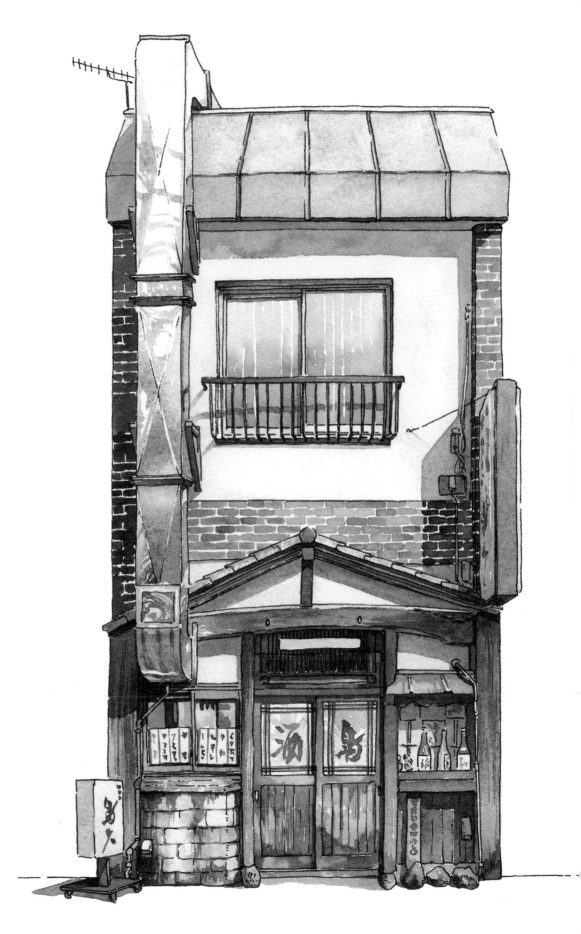

阿佐谷 Asagaya　肉醬屋

44 ミート屋 Miito-ya

這家店位在阿佐谷商店街上，專賣肉醬義大利麵。左側的鐵皮屋頂形成獨特的工業風氛圍，是這家店最初引起我注意的部分。人潮多時，客人會在這個屋頂下排隊等待。即便如此，我仍不禁猜想這棟建築之前是什麼用途⋯⋯。

Located in the shopping street of Asagaya, Miito-ya is a shop that specializes in meat sauce pasta. The steel roof on the left creates a unique industrial atmosphere, which first piqued my interest in this shop. When it is crowded, customers wait their turn underneath this roof. Even so, I wonder what this building was used for before...

店家的新商標設計大膽，不過仍然使用了傳統日式的圓圈設計。我個人很喜歡。

You can see that the shop has a bold new logo, but still uses the traditional Japanese circle design. Personally, I like it.

正門其實是出口。此處有一面牌子，告訴客人應該從建築物左側的後門進入。

The door in front is actually the exit. There is a sign telling customers that they must enter from the back door on the left side of the building.

整個廚房和專用的料理工具，都能從店鋪正面和側面的大窗戶看見。

The entire kitchen with its specialized appliances can be seen through the shop front and large windows on the side.

這家店大部分的陳設都非常俐落、一絲不苟，但是店門口卻擺了三張不成套的兒童椅，高矮形狀各異。這個有趣的小細節令我會心一笑。

While this shop is, for the most part, precisely and systematically furnished, the three children's chairs in front are mismatched both in height and shape. I find this detail very charming!

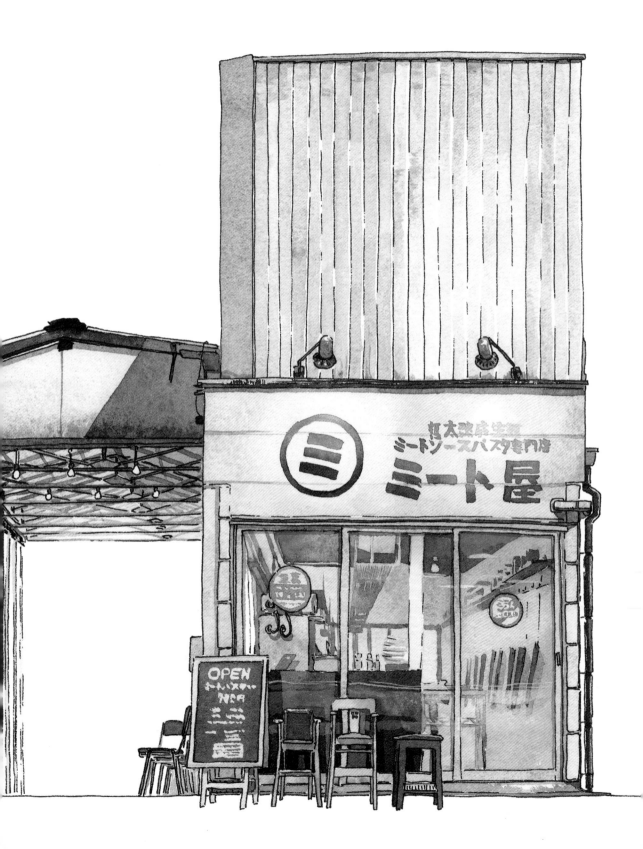

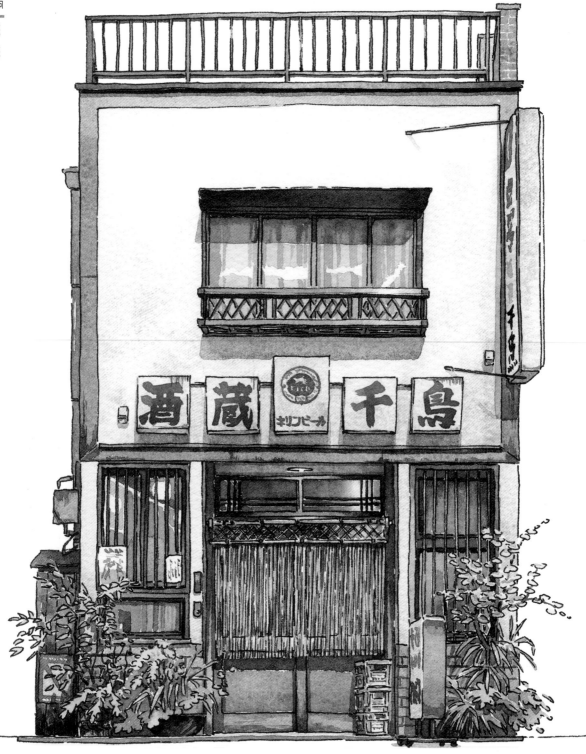

45 酒蔵千鳥
Sakagura Chidori

酒蔵千鳥是位在西荻窪附近的居酒屋。在這裡可以吃到傳統的日式下酒料理,像是生魚片、烤魚,還有關東煮。建築物俐落的外觀極具魅力,內部的格局則很有意思,還有一座特別的U形吧台。

Sakagura Chidori is an *izakaya* in Nishi-ogikubo. Here, you can eat traditional Japanese pub fare, such as sashimi, grilled fish, and *o-den*. While the clean exterior is very appealing, the interior of this shop has a very interesting build and features a U-shaped counter.

我們造訪這家店的那一天正下著雨,而且抵達餐廳時已經傍晚,即將天黑。我拍下的照片一片黑暗,店內的溫暖光線從木製窗飾的間隙透出,吸引著我們入內。我試著在插畫中表現出這個感覺。

It was raining on the day we went to see the shop, plus we arrived at the restaurant late in the evening. The photo I took in the darkness shows warm light spilling through the wooden window decorations from the inside of the shop, as if it were inviting us in. I tried to feature this in the illustration.

建築物之間最狹小的空間也被充分利用。這裡有一扇小木門,裡面是餐廳店員的使用空間。

Even the smallest space between buildings is used. Here were small wooden doors, creating a space for the restaurant staff to use.

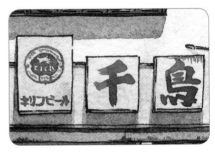

傍晚時招牌會亮起,大大的深藍字體非常醒目。中間的部分是一家老牌啤酒廠(Kirin)的商標。

This sign lights up in the evening, with large, deep blue letters that really stand out. The middle part has an old beer manufacturer (*Kirin*) logo on it.

門口掛著一片類似草編繩的暖簾(繩暖簾),不同於一般布製暖簾,是充滿造型感的另一種選擇。

In the entrance, there is a kind of woven reed rope curtain (*nawa noren*). A stylish alternative to the usual fabric *noren*.

內部請見下一頁 ▶

◀ 外觀請見前頁

|4|5| 酒蔵千鳥 Sakagura Chidori

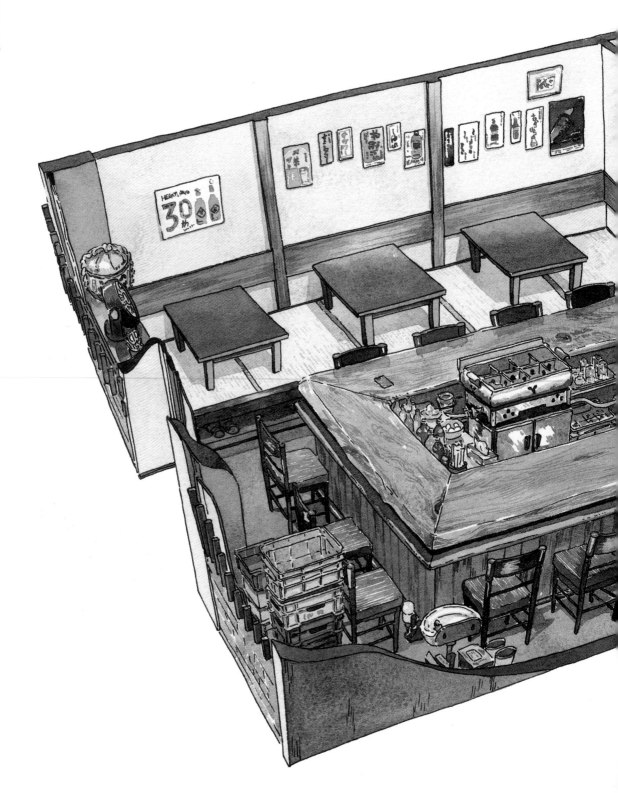

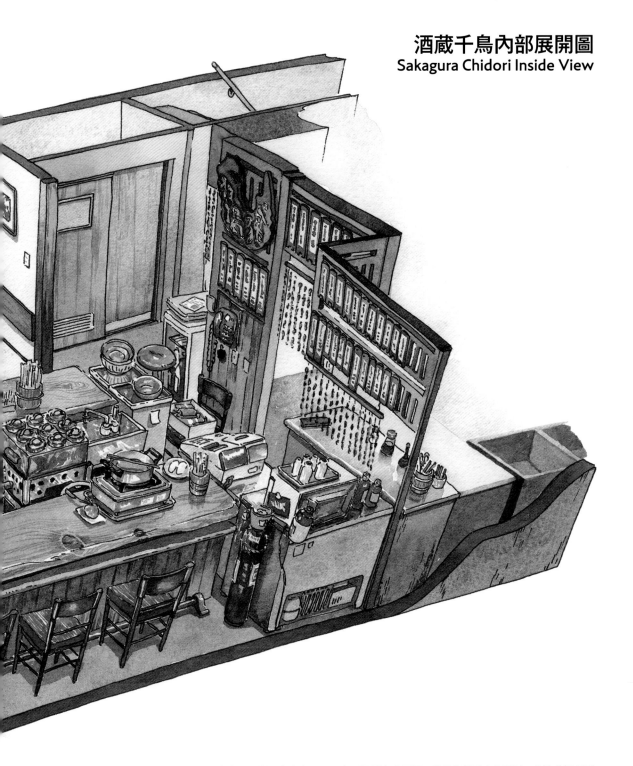

本書介紹的店家中，只有這家店有U形吧台。這種老式居酒屋常見的特殊室內設計，真的非常吸引我。吧台後方擺放著一整排日本獨有的料理工具，像是關東煮保溫鍋或清酒溫酒器。

Of the shops featured in this book, this was the only one with a U-shaped counter. The distinctive build of this interior, often seen in old-style *izakayas*, really pulled me in. Behind the counter was a whole lineup of cooking appliances unique to Japan, such as *o-den* warmers and sake warmers.

46 ポパイ Popeye

西荻窪 Nishi-ogikubo　卜派

這家店提供修鞋和打鑰匙的服務,工作俐落快速而且價格實惠,因此評價很好,當地客人總是絡繹不絕。建築物上方的招牌已褪色且出現生鏽跡象,看起來相當老舊,黃色底板上貼著切割的文字。我利用陰影,試圖表現招牌上的字體厚度。

Popeye is a shoe repair and key shop. Its clean work and fast, affordable service has earned it a good reputation, and it is constantly visited by locals. The sign on top of the building looked old and was made using cutout letters against a yellow background. I tried to show the thickness of the letters here using shadows.

我非常喜歡由一片片深邃的藍色波浪小屋瓦鋪成的屋頂。

I really like these small *kawara* tiled roofs, made with tiles of the deepest, dark blue.

二樓陽台外面的冷氣主機隨便放在角落,看起來搖搖欲墜。

The air conditioning units outside were placed haphazardly at angles, looking highly unstable.

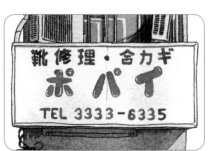

從設計和建築物構成的面向來看,掛在一樓和二樓之間的招牌應該是後來加上的,遮住了其中一層小瓦片鋪成的屋頂。

Judging from the design and how it was made, this sign between the first and second floors is probably a later addition covering another one of the little tiled roofs.

我試著描繪鮮黃色的折疊式遮雨棚在玻璃門上形成的倒影。

I tried to depict how the bright yellow foldable marquee reflected in the glass of the shop doors.

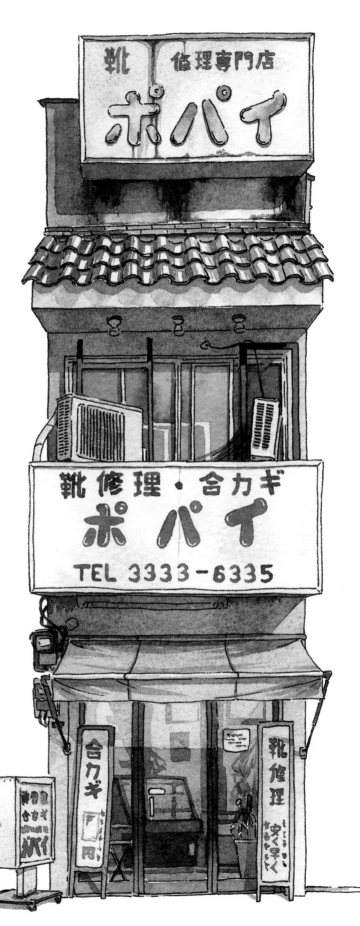

吉祥寺 Kichijōji 庫庫廚房

47 キッチンククゥ
Kitchen KUKU

這家店其實座落在一棟建築物的一角,建築物裡有許多商家和餐廳。嚴格來說,這家店不應該出現在本系列中,但是我實在太喜歡它的外觀了,因此決定把它分割出來,「解放」這家店!

This shop is actually a part of a larger building with many shops and restaurants in it. Technically it should not be included in this series, but I liked the exterior so much I decided to cut out the rest and "free" it.

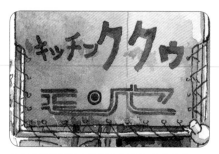

此處的商標設計風格是別緻的復古未來風,和本書中我畫下的其他招牌很不一樣。

The logo used here has an elegant retro-futuristic design. It's quite different than all the other signs I painted in this book.

巨大的金屬通風管為這家店帶來質樸的美感。

The huge metal air duct gives the store a nice rustic aesthetic.

捧著一大鍋湯的熊造型立板絕妙無比,顏色正好搭配橘色的塑膠屋頂!

The stand in a shape of a bear holding a large pot is just excellent! It creates nice color synergy with the plastic orange roof.

我很喜歡整棟建築以樓梯當作入口的設計。不過在畫面中很難表現出這個樓梯有多麼陡!

I like how the whole entrance to this building is just stairs. However, it was quite difficult to show how steep they were.

48

吉祥寺＋神樂坂　Kichijōji+Kagurazaka　　石村輪業＋神樂坂自行車

石村輪業＋神楽坂サイクル
Ishimura Cycle ＋ Kagurazaka Cycle

這篇是本系列插畫的特別版，我結合兩家不同的腳踏車店，選擇其中吸引我的細節畫成一幅畫，這兩家店都充滿魅力，因此我非常喜歡這幅幻想的結合之作。

I have combined the details I liked from two different bicycle shops called Ishimura Ring Industry and Kagurazaka Cycle into one image, making this a special illustration in the series. Both shops are very appealing, so I like this imaginary collaboration very much.

這個半虛構的店面很明顯分成數層樓，因此我改變顏色，讓樓層之間的差異更鮮明。

This partly made-up shopfront is clearly divided into stories, so I changed the colors to make the difference even more visible.

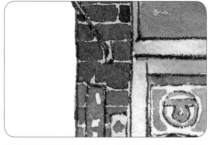

我非常喜歡深色的磁磚。神樂坂自行車店鋪外牆的磁磚在太陽下映出明亮反光，但是在陰影中則保有深邃的藍綠色。

I really liked the deep colored tiles. The tiles on the outer wall of Kagurazaka Cycle reflected the sun brightly but stayed deep green-blue when in the shadows.

我希望這家店鋪能有個漂亮的商標看板，因此決定除了神樂坂自行車之外，加入我在吉祥寺發現的另一家腳踏車店——石村輪業。招牌上的紅色文字是半立體的，有如浮出白色背景，顯得非常有意思。

I wanted a nice logo on the shop, so I decided to combine the Kagurazaka Cycle with a second bicycle shop I found in Kichijoji, Ishimura Cycle. The red letters on this sign were created as a relief and seem to pop out against the white background, making it very interesting.

天空和周圍的電線桿與纜線全都清晰地映在玻璃上。此外，我也盡量試著表現折疊式遮雨棚的倒影。

The sky and surrounding electric poles and wiring reflected clearly in the glass. I also tried to paint the reflection of the foldable roof the best I could.

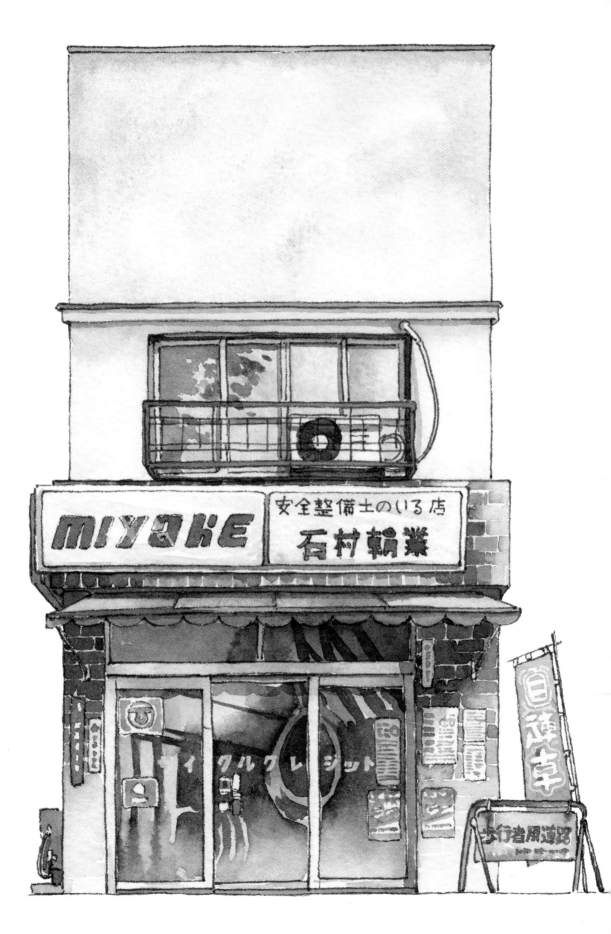

49

だるま堂（歇業／私人住宅）
Daruma-do（Closed/Private-house）

這家店過去販售日式甜品和便當，但是現在已經歇業，改為私人住宅。店鋪正面厚實的酒瓶綠遮雨棚首先抓住我的目光。古色古香的瓦片看起來非常堅固厚重，我盡量在畫中表現出這種感覺。

Once a seller of Japanese sweets and packed lunches, Daruma-do closed down and was turned into a residence. This heavy looking deep bottle-green canopy roof was the first thing that struck me about the design of this storefront. These old *kawara* roof tiles look very sturdy and heavy, which I tried my best to show here.

店鋪的每個細節似乎都是訂製的。連門口的燈也很別緻，周圍和燈罩上都是花朵圖樣。

Everything about this storefront looks order-made. Even the lamps are unique with a floral pattern on and around them.

牆面的磁磚也非常特別。不僅是鮮豔的磚紅色，表面還呈現凹面，賦予牆面耐人尋味的質地和陰影。

The wall tiles were unique. Not only were they a bright brick-red color, they were concave, which gave the wall really interesting texture and shadows.

拉門也是訂製的，邊緣都是細緻的花紋。

The sliding doors were also customized with a delicate floral pattern along the edges.

店外的塑膠容器裡有幾隻烏龜，在裡頭快活地晃蕩，好似正在清理容器一樣。

There were turtles in the plastic container boxes outside the shop. Rattling around their container in a lively manner, these turtles appeared to be cleaning it.

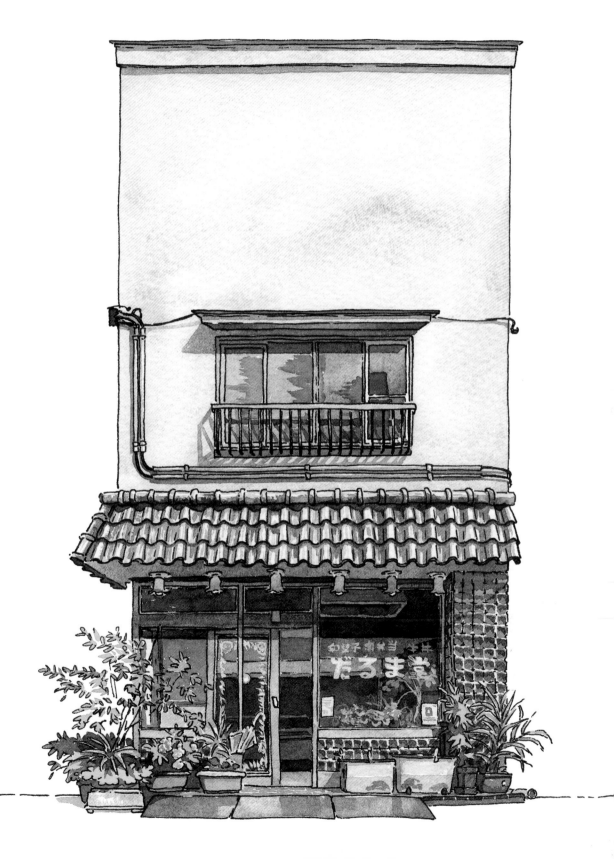

分倍河原 Bubaigawara　　陽光理容室

50 サニー理容室
Sunny Barber Shop

這家理容室位在分倍河原一帶，雖然離「中央線」地鐵站很遠，但是這棟獨具魅力的出色建築絕對值得親眼目睹。陡峭的屋頂深深嵌入兩側的牆，令這家店的外表與眾不同。我試著重現側邊牆面形成的陰影，以及屋頂木板的歲月痕跡。

Though it is far from the Chuo Line station (Sunny Barber Shop is located in an area called Bubaigawara) it is an extraordinary building worth visiting. The steeply angled roof between deep side walls gives this shop a unique appearance. I tried to recreate the shape of the shadows made by the side walls and the weathered appearance of the roof shingles.

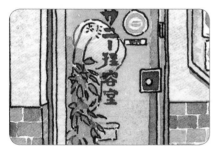

透過玻璃門可以看到一個老式造型的吹風機。我還小的時候，這種造型怪異的吹風機總讓我很不自在。

There's an old-fashioned looking hair drier visible through the glass door. When I was a kid, those strangely shaped driers made me uneasy.

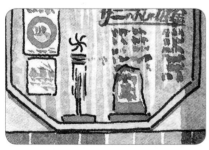

消防工具「纏」的縮小模型，這是日本江戶時代的消防員用來告知住戶和其他消防員起火點位置的工具。

A miniature of a *matoi*, used in Japan by Edo period firefighters to notify residents and other firefighters of fire.

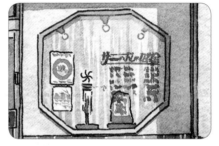

窗戶不是方形的，這也是整體設計中另一項獨特的元素。

The window is not square, creating another unique element in the design.

雖然在這本書中我已經說過許多次，不過我就是很喜歡這種深藍色的磁磚。每一塊磁磚的顏色皆不盡相同，從土耳其藍到深藍色都有。

I've touched on this many times in this book, but I really like these deep blue tiles. Each of them is slightly different in color, with some going as far as turquoise and deep blue.

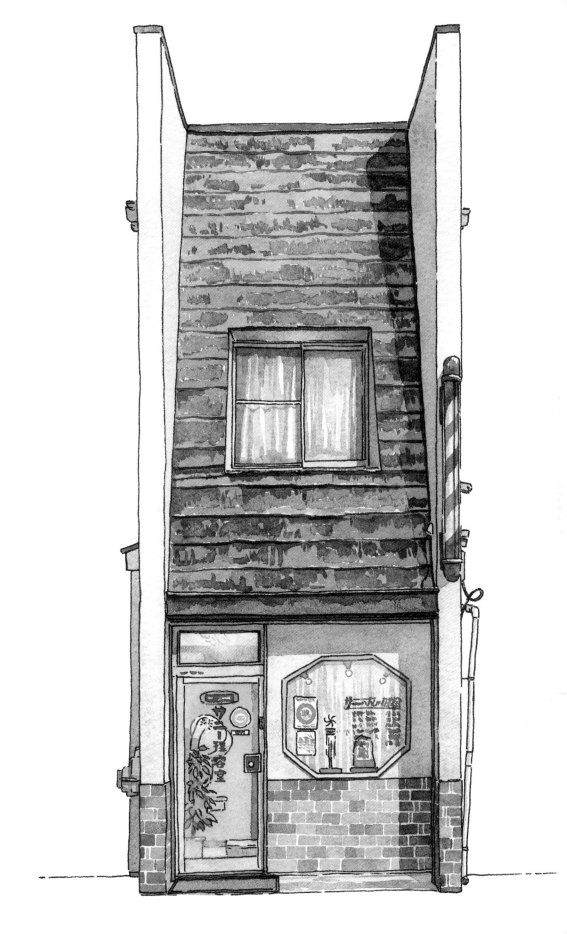

店鋪資訊
05
—

42 さいとう Saitou

地址：杉並区阿佐ヶ谷南1-47-14
落成年份：1936 年
附註：這家店的營業時間完全看
　　　店主心情！

Address:
1-77-14 Asagaya Minami,
Suginami-ku
Year built: 1936
Note: The store opens and closes
depending on the owner's
schedule!

43 鳥久 Torikyu

地址：杉並区阿佐ヶ谷南2-12-22
落成年份：1980 年代
附註：這間店的烤雞肉料理是出名的
　　　美味，因此總是座無虛席。

Address:
2-12-22 Asagaya Kita, Suginami-ku
Year built: 1980s
Note: With its famously delicious
yakitori, this shop is always full.

44 ミート屋 Miito-ya

地址：杉並区阿佐ヶ谷南1-36-7
落成年份：1980 年代
附註：肉醬義大利麵上可以加茄子，
　　　甚至還可以加納豆！

Address:
1-36-7 Asagaya Minami, Suginami-ku
Year built: 1980s
Note: Meat sauce pasta can be topped
with eggplant or even natto!

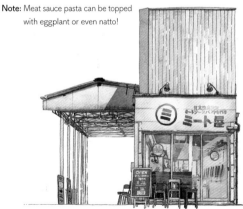

45 酒蔵千鳥 Sakagura Chidori

地址：杉並区西荻南3-10-2
落成年份：2000 年
附註：1955 年開業，擁有不少長
　　　年光顧的常客。

Address:
3-10-2 Nishiogi Minami,
Suginami-ku
Year built: 2000
Note: Opened in 1955, many
of the regulars have been
coming here for years.

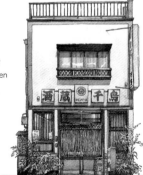

4 6 ポパイ Popeye

地址：杉並区西荻南3-9-7
落成年份：1930 年代
附註：一走出西荻窪站，這家店就
　　　在你面前！

Address:
3-9-7 Nishiginami Suginami-ku
Year built: 1930s
Note: The shop is right before you
when you exit Nishi-ogikubo
Station!

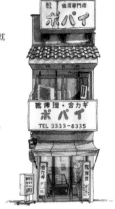

4 7 キッチンククゥ Kitchen KUKU

地址：武蔵野市吉祥寺本町2-17-2
落成年份：1960 年代
附註：店內有許多可愛的青蛙插畫
　　　和小雕像。

Address:
2-17-2 Kichijoji Honcho, Musashino city
Year built: 1960s
Note: Inside the store are many cute
illustrations and figurines of
frogs.

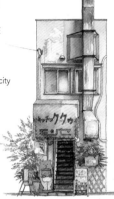

4 8 石村輪業＋神楽坂サイクル Ishimura Cycle＋Kagurazaka Cycle

石村輪業
地址：武蔵野市吉祥寺本町3-7
落成年份：1970 年代晚期
附註：他們的標語是「買得安心、
　　　騎得安全的自行車店」。

Ishimaru Cycle
Address:
3-7 Kichijoji Honcho, Musashino city
Year built: Late 1970s
Note: Their motto is "A store for
bicycles that are safe to buy
and safe to ride".

神楽坂サイクル
地址：新宿区矢来町107
落成年份：1970 年
附註：這家店販售許多很難找到
　　　的單車，愛車人士的必訪
　　　之店。

Kagurazaka Cycle
Address:
107 Yaraicho, Shinjuku-ku
Year built: 1970
Note: This shop sells many bicycles
that are difficult to find, so
bicycle lovers must check it
out.

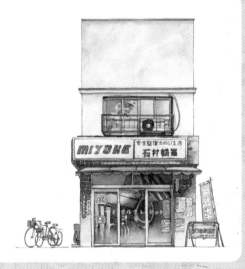

4 9 だるま堂 （歇業 / 私人住宅） Daruma-do (Closed/Private-house)

地址：祕密（因為是私人住宅）
落成年份：1968 年
附註：當年這是東小金井第一家
　　　沒有鐵門的店鋪呢。

Address:
Secret (because it is a private
residence)
Year built: 1968
Note: At the time, it was the first
shutterless shop in Higashi
Koganei.

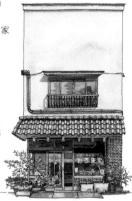

5 0 サニー理容室 Sunny Barber Shop

地址：府中市片町2-2-1
落成年份：1950 年代
附註：這棟建築是重建的街屋，
　　　因此造型狹長。

Address:
2-2-1 Katamachi, Fuchu city
Year built: 1950s
Note: The reason the building is
long and narrow is because
it is a renovated tenement
house.

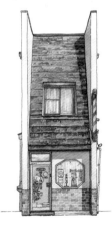

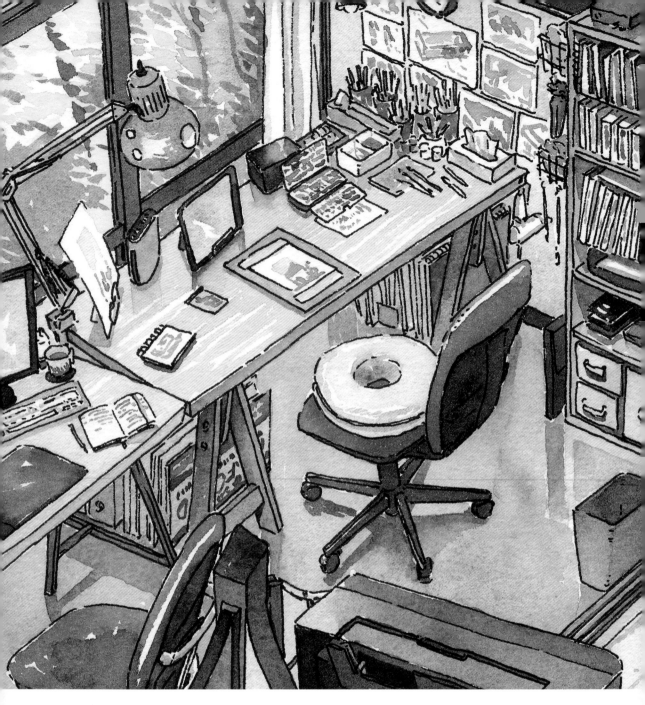

工作室　Room ·· 136
工具　Tools ·· 140
作畫方式　How To ·· 148

第6章
Chapter6

Mateusz的
工作室
Mateusz's atelier

工作室 Room

目前我和同為插畫家的太太香苗一起生活、工作，我們住在江之島附近一棟昭和時期建造的日式房屋。江之島距離東京約一個多小時車程，是非常美麗的觀光勝地，不論到湘南海岸或前往座落許多歷史悠久的寺廟及店鋪的鎌倉都很方便。

我們將工作空間分成地板區和疊蓆區。地板區是我和香苗的手繪區。疊蓆區有我的電腦，用來編輯圖檔和製作電腦繪圖，還有兩人吃飯和休閒時間用的矮桌。

工作室最得我心的部分就是窗外蓊鬱的景致。寬廣的庭院連接自房東家的一部分，每個季節都有各式各樣的花朵綻放，也有許多鳥兒造訪。美麗的景色為漫長的作畫時光增添些許閒適。從我們的房子步行就能抵達海灘，因此我們常會慢慢散步，當作休息和尋找靈感。

Currently, I live and work with my wife Kana (who is also an illustrator) near Enoshima in a nostalgic Japanese-style house built during the Showa Era. Little more than an hour from Tokyo, Enoshima is a wonderful sightseeing spot with a lot of unique sights along the shore located close to the historic city of Kamakura.

The work space is separated into a flooring and *tatami* mat areas. On the floor, I have my drawing and painting table as does Kana. In the *tatami* area is my computer, I use for for all the digital editing and painting, and a low dining table used for meals and leisure time.

Our favorite part of this place is the lush green view. The huge garden, belonging to the land owner's house, has all kinds of flowers blooming depending on the season, and many kinds of birds visiting. The view makes long hours spent on painting and drawing more relaxing. Our house is also within walking distance to the beach so we often go for long walks for rest and inspiration.

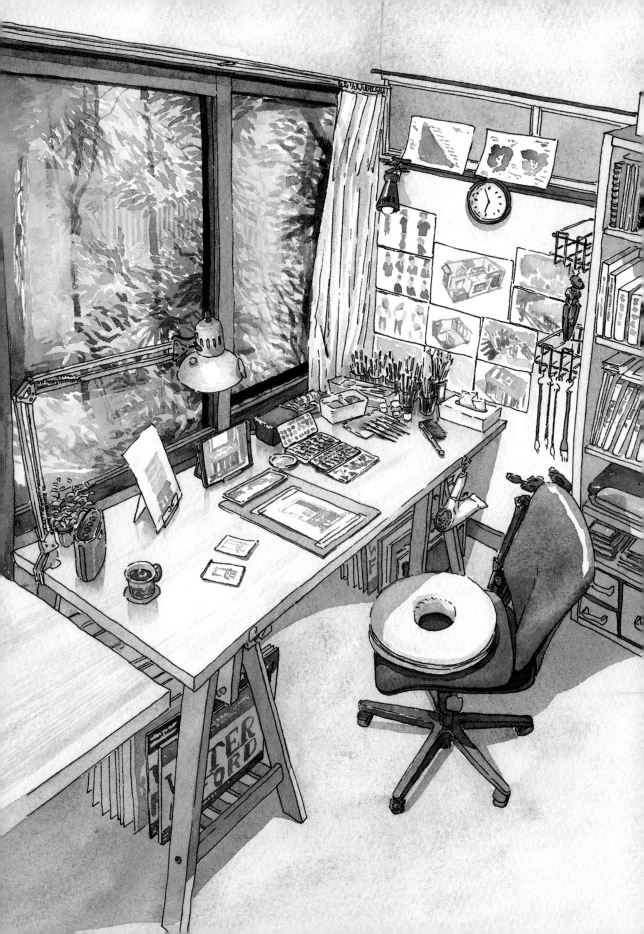

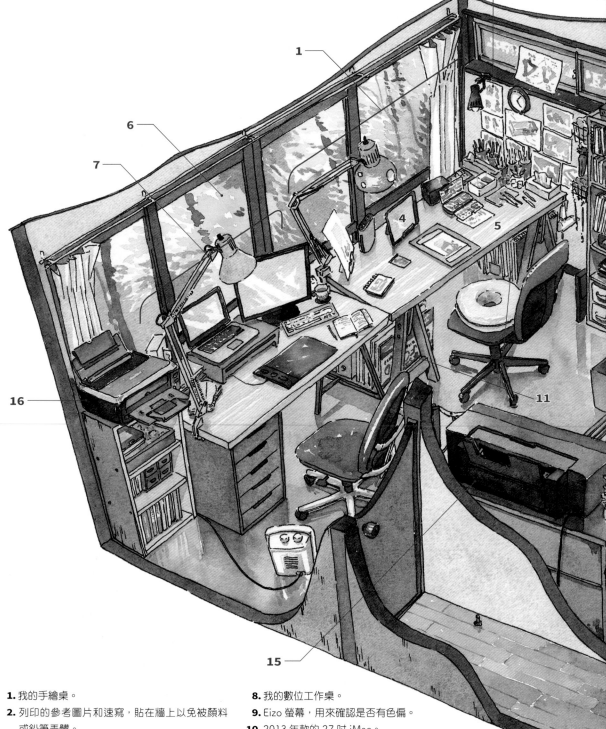

1. 我的手繪桌。

2. 列印的參考圖片和速寫，貼在牆上以免被顏料或鉛筆弄髒。

3. 書架上放滿參考用書。大部分都是吉卜力工作室的美術設定集、漫畫、分鏡書籍，以及背景美術設定畫冊。

4. 我的 iPad PRO，用來展示參考照片。

5. Schmincke 水彩組。

6. 外面是綠油油的庭院。

7. 香苗的桌子，以及她的筆記型電腦和繪圖板。

8. 我的數位工作桌。

9. Eizo 螢幕，用來確認是否有色偏。

10. 2013 年款的 27 吋 iMac。

11. 收納在桌子下的水彩紙。

12. 喇叭。

13. Wacom 繪圖板，數位繪圖用。

14. 我的烏克麗麗，有時候休息時會彈著玩。

15. Epson 大型印表機，專門用來印製在網路上販售的複製畫。

16. Canon 小印表機，日常列印用。

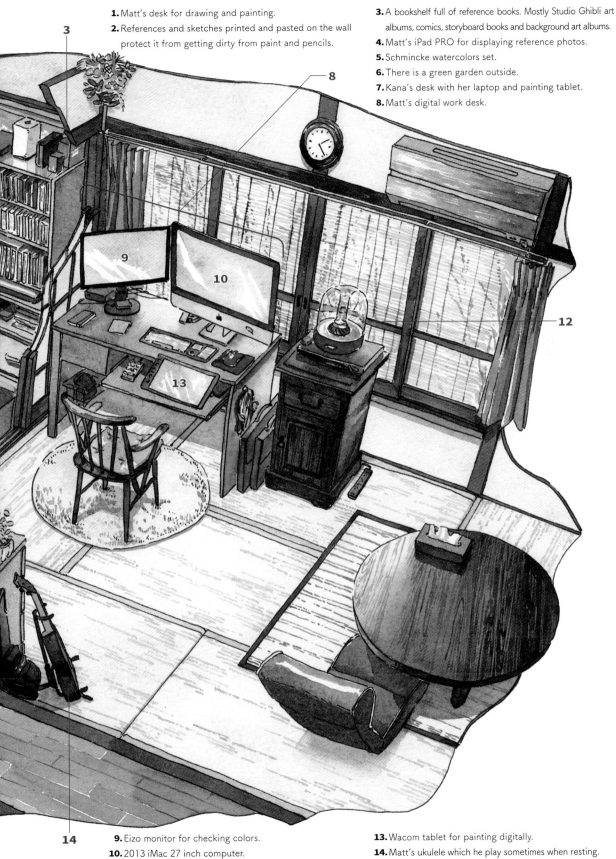

1. Matt's desk for drawing and painting.
2. References and sketches printed and pasted on the wall protect it from getting dirty from paint and pencils.
3. A bookshelf full of reference books. Mostly Studio Ghibli art albums, comics, storyboard books and background art albums.
4. Matt's iPad PRO for displaying reference photos.
5. Schmincke watercolors set.
6. There is a green garden outside.
7. Kana's desk with her laptop and painting tablet.
8. Matt's digital work desk.
9. Eizo monitor for checking colors.
10. 2013 iMac 27 inch computer.
11. Watercolor paper stock under the desk.
12. A speaker.
13. Wacom tablet for painting digitally.
14. Matt's ukulele which he play sometimes when resting.
15. Big Epson printer for making art prints to sell online.
16. Small Canon printer for everyday printing.

工具 Tools

顏料

繪製這本書時，我主要是使用 Schmincke 品牌的水彩顏料組。色譜上的各個顏色彩度都很飽和鮮明，這點深得我心。

我使用的是標準48色組，另外加上幾個顏色：

370 陶瓷粉
361 永固紅
512 氧化鉻綠
536 綠黃
530 樹綠
417 鈷洋紅（Daler Rowney 品牌）

我喜歡手邊隨時有許多顏色，這樣當我想畫圖就不必混色，可以節省許多時間，尤其是繪製店鋪系列這類色彩繽紛又有許多細節的作品。

Paints

The main set I used for this book is made of Schmincke brand watercolors. I like them for their vibrant colors consistent along the entire spectrum.

I use the standard 48 color set with some additional paints:

370 Potter's Pink
361 Permanent Red
512 Chromium Oxide Green
536 Green Yellow
530 Sap Green
417 Cobalt Magenta (Daler Rowney brand)

I like to have a lot of colors on hand so I don't have to mix them every time I want to paint. This saves a lot of time, especially while working on such colorful and detailed illustrations like shop-fronts.

半塊塊狀水彩

這種製作成小方塊的半塊塊狀水彩，是我主要使用的水彩顏料，能依照需要和喜好，隨意更換排列放入我的水彩組。不過有時候我也會買管裝水彩，將之擠入用完的半塊水彩塑膠盒，因為管裝水彩稍微便宜一些。

Half-Pans

I mostly use watercolors that come in small cubes called half-pans so I can swap and line them up in my set as I wish, but sometimes I also buy watercolors in tubes and squeeze them into empty plastic half-pans. The tube paint is a little bit cheaper.

陶瓷洗筆桶

這種陶瓷洗筆桶在日文中叫做「筆洗」。我看到宮崎駿使用這種洗筆桶，所以我也要買來用！這種洗筆桶大又重，最適合在畫室使用，即使使用壓克力顏料也能輕鬆清洗乾淨。我大力推薦買一個，任何水溶性顏料都適合！

Ceramic Water Tank

It's a ceramic brush cleaning tank called *hissen* in Japanese. I saw Hayao Miyazaki using a water tank like this and just had to buy it! It's big, heavy and perfect for studio painting. It is easy to clean even when using acrylic paint. I strongly recommend buying one of these for any water-based painting!

陶瓷調色盤

這是我在無印良品買的瓷盤，其實原本是浴室用托盤。但是當做畫室調色盤效果出乎意料的好——穩定、潔白（方便判斷顏色）而且容易清洗。此外，我也和許多以廣告顏料作畫的日本動畫背景畫師一樣，會用一些較小的圓形瓷盤當作調色盤。

Ceramic Palette

A ceramic dish that I bought in the MUJI store that was originally meant to be used as a toiletry stand. It works as a studio palette surprisingly well - it's stable, white (which makes it easy to determine colors) and is easy to clean. I also use some smaller ceramic dishes used often by Japanese animation background painters that work with poster color paints.

畫筆

繪製這本畫冊的過程中，我使用了許多畫筆，由於我的喜好經常變化，以下是幾款我最推薦的畫筆：

Brushes

I used a lot of brushes throughout the making of this album and while my favorites changed a lot, I can recommend some of the best:

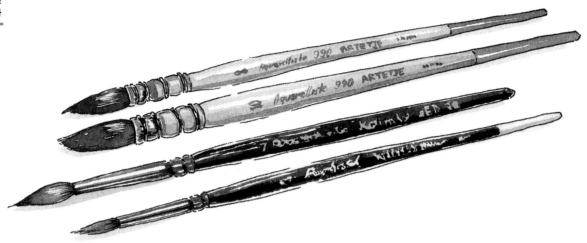

ARTETJE Aquarelliste 990
水彩筆，10&12 號

品質絕佳又不貴的人造毛水彩筆，吸附水分和顏料的能力佳，同時又有俐落的筆尖。

ARTETJE Aquarelliste 990
Mop brush size 10&12

Great, inexpensive artificial hair mop brush that can hold a lot of water and paint and has a nice, sharp tip at the same time.

Rosemary & Co.
西伯利亞貂毛水彩筆，系列 33，7 號

西伯利亞貂毛（Kolinsky Sable）製成的水彩筆。我尤其喜愛33 系列的畫筆筆尖形狀。

Rosemary & Co.
Kolinsky Sable Ser. 33 size 7

A brush made from Kolinsky Sable (Siberian ferret hair). I especially like the shape of the brush tip in series 33.

拉斐爾 8402 西伯利亞貂毛水彩筆，3 號

拉斐爾品牌的天然西伯利亞貂毛，可以說是用來畫水彩的最佳筆毛。筆尖俐落，能穩定釋出水分和顏料。我很常使用這隻筆，連小細節也不例外。不過缺點是價格高昂。

Raphael 8402 KOLINSKY size 3

A Raphael version of the famous Kolinsky brand natural hair brush - probably the best for watercolors. It has a sharp tip and can release water and pigment steadily. I used this brush a lot, even for the smaller details. The downside is its high price.

拉斐爾 845 雙倍吸水尼龍毛水彩筆，
8&10 號

這支人造毛的畫筆是模仿喀山松鼠毛製成。功能性絕佳——吸水性強、能穩定釋出水分和顏料，而且還有俐落的筆尖。算是天然動物毛畫筆之外，物美價廉的另類選擇。

Raphael SoftAqua 845 size 8 & 10

These artificial hair brushes are made to imitate the petit-gris squirrel fur. They work great - they hold and release water and pigment well and have a sharp point. These brushes offer a high quality, inexpensive alternative to the natural hair brushes.

奶油刀

我用這種較鈍的刀子取下整疊的膠裝水彩紙（四邊皆上膠）。雖然在膠裝狀態下也能作畫，我還是選擇取下紙張，先修剪成適當的尺寸，然後用紙膠帶固定在薄木板上。

———

Butter Knife

I use this dull knife to free the watercolor paper sheets from the block they come glued too (they are glued on all four sides). Even though one can use them when they are still glued in place I cut them free, trim them to my preferred size, and tape them to a thin wooden board.

白色（舊）毛巾

畫水彩時的重要工具。我用毛巾控制水彩筆中的水分含量。只要在毛巾上輕觸筆尖，吸去多餘水分即可。隨著畫作進展，毛巾也會變得越來越髒。

(Formerly) White Towel

An essential tool for painting with watercolors. I use it to control the amount of water in my watercolor brush. Just touch the tip of the brush gently to the cloth to absorb excess water. The towel gets dirtier and dirtier as work progresses.

———

山度士瓦特夫
白色冷壓水彩紙

這是厚度300g/m 的水彩紙，以價格而言是非常高品質的紙張，而且是目前為止我覺得最好用的紙。我使用的水彩技法不需要太多水份，因此這款紙不會起皺（而且還貼在木板上）。此外，紙張表面也較粗糙，經得起硬質鉛筆速寫、經常用橡皮擦擦拭，而且上墨效果非常好（墨水不會沿著毛細滲漏、滲透或暈染）。而且用這款紙來畫水彩非常享受，因為能讓色彩變換順暢，上色平順均勻，還有漂亮的紋理。

SAUNDERS Waterford
White Cold Pressed Watercolor Paper

This thick 300 g/m watercolor paper has really high quality relative to its price and is one of the best I have used so far. In my watercolor painting style I don't use so much water so this paper does not warp (especially when it's taped to a board). It also has a rather unyielding surface so it handles sketching with hard pencils, intensive erasing, and ink very well (the ink does not seep through, bleed, nor spread). At the same time it's a pleasure to use watercolors on this paper as it gives smooth color transitions and really flat, even washes with beautiful, textures.

馬汀博士
超白防暈墨水

裝在小玻璃罐裡的白色不透明顏料，使用起來非常便利，而且覆蓋力很不錯。畫面中某些白色細節和亮點無法光靠留白膠達到效果時，我就會使用這款顏料。因為留白膠無法呈現半透明效果，而且黏性高，有時使用起來並不容易。雖然品牌並不建議在這款白色顏料中混入其他顏料，我還是會這麼做，讓某些部分的水彩較不透明，有如不透明顏料。

Dr Ph. Martin's
Bleed Proof White

This is white, opaque paint in a small jar, really easy to use, with relatively good covering strength. I used it for some white details and highlights that were hard to achieve even with the help of masking fluid. Because masking fluid cannot be made half-opaque and has relatively high viscosity, it is sometimes hard to use. Though the maker doesn't recommend mixing this white with other paints, I used it to make watercolors more opaque in some places, like I was using gouache.

吳竹
白墨 30

這一款不透明白色顏料我主要用來修正錯誤。覆蓋力強，但是過於厚重時可能會龜裂。

Kuretake
White INK 30

Another opaque white paint I used mostly for correcting mistakes. It has good covering strength but can crack if applied too thickly.

好賓
留白膠

我在這些插畫中使用大量留白膠（以舊的小畫筆塗上）。留白膠非常適合用來繪製深色背景上的繁複細處，像是文字、招牌或亮點。

HOLBEIN
Masking fluid

I used a lot of masking fluid (applied with an old, small brush) in these illustrations. It comes in very handy when painting intricate white details on dark backgrounds, such as letters, logos, or highlights.

洛登
黑色墨水

我用的是洛登（Rotring）製圖針筆專用的黑色墨水。這款墨水的黑色非常漂亮，而且完全防水。在紙張上也乾得很快，因此不會不小心沾到手而弄髒畫面。

※ 注意：洛登的白色墨水包裝非常相似，我有一次不小心買錯了！

ROTRING
black ink

I used the original Rotring black ink, intended only for isograph pens. This ink is beautifully black and fully waterproof. It also dries really fast on paper, so I's hard to smudge it by hand on accident.

*Warning: the white ink from the same brand comes in a similar package and I once bought it by mistake!

—

蜻蜓牌 MONO
橡皮擦

這塊超優秀的橡皮擦即使在充滿紋理的水彩紙上也能擦得乾乾淨淨。畫底稿和上完墨線後要完全擦去鉛筆線稿時，我都會使用這款橡皮擦。

TOMBOW MONO
Plastic Eraser

A great eraser that works well even on textured watercolor paper. I used it while sketching and to completely erase the pencil underdrawing after the ink lines were finished.

—

日東電工
紙膠帶

我的日常工作中大量使用這款紙膠帶，撕起後可使畫作邊緣保持乾淨整潔。繪製本系列時，主要用來將水彩紙平整地固定在畫板上。

NITTO
masking tape

I use this tape a lot in my everyday work to make the edges of paintings nice and even after I peel it off. This time I used it mainly to hold the watercolor paper flat on the board.

筆　Pens

三菱 UNI-ball SIGNO 白色中性鋼珠筆

某些需要畫細緻白線或字體的地方，我會使用這款中性鋼珠筆，使線條穩定、粗細一致。畫畫時手邊有一支非常方便，畫在已乾透的水彩上效果很好，而且筆頭不會阻塞。

White Uni-ball SIGNO Gel Pen

I used this gel pen in several places for thin white lines or lettering that required stable lines of constant thickness. It's useful to have on hand while painting because it works well when applied onto dried watercolors and does not clog.

洛登 ISOGRAPH 0.50mm 針筆

剛開始繪製本系列插畫時，我用 COPIC 代針筆（0.7mm）畫墨線，但是我希望線條能更細更穩定，因此最後用針筆繪製大部分的作品。我用的是洛登 Isograph 筆尖0.50mm 的製圖針筆，在日本很受歡迎。出墨非常順暢（即使在水彩紙上，線條也不會像毛氈筆尖的代針筆容易斷斷續續），而且我完全沒有遇到任何阻塞無法出水的問題。

ROTRING ISOGRAPH 0.50mm

I started illustrating this series with a COPIC multiliner (0.7mm) for line-work but I wanted the lines to be a little thinner and more stable, so in the end, I used a rapidograph for most of the pieces. I used the 0.50mm tip Rotring Isograph, which is popular in Japan. It has a very stable ink flow (even on watercolor paper the lines don't break as easily as when drawing with a felt-tipped multiliner), and I didn't have any problems with clogging.

三菱 Hi-Uni 鉛筆，硬度 F

我試過許多日本品牌的鉛筆，大部分都相當喜愛，但是對我來說，Hi-uni 鉛筆才是上上之選（緊接著是蜻蜓牌的鉛筆）。我很喜愛該品牌鉛筆筆下滑順又深濃的線條。由於這些特點，日本動畫界廣為使用 Hi-uni 鉛筆繪製動畫影格。不過我覺得相同的硬度，日本鉛筆比歐洲鉛筆軟多了，因此繪製這本書時，我用硬度相對較高的 F 鉛筆，只在水彩紙上畫底稿，上完墨線後即擦去。

Mitsu-Bishi Hi-Uni grade F

I have tried a lot of Japanese brand pencils and liked most of them but for me, the Hi-uni pencils are the best (closely followed by TOMBOW brand). I love the silky feel and dark lines they make. Because of these characteristics, they are widely used in Japanese animation for drawing animation frames. I feel that Japanese pencils are a lot softer than European pencils of the same grade.
For this book, I used the relatively hard F grade pencil just for the initial sketch on the watercolor paper, to be erased once the lines are inked.

工作流程

這本書中所有的插圖都是利用墨水及顏料，在紙張上繪製而成。不過插圖必須數位化後編輯，才能完成本書。這個過程中，我將數位修改和編輯的程度降至最低。數位步驟，我使用 iMac 電腦，軟體是 ADOBE Photoshop，並搭配 Wacom Cintiq 13HD 繪圖板。掃描畫作使用的是 CANON CanoScan 9000F Mark II 掃描機。

Workflow

All illustrations in this book were made using ink and paint on paper. However, they needed to be digitized and edited to create this book. In doing so, I tried to keep digital retouching and editing to a minimum.
For the digital process, I used ADOBE Photoshop on an iMac with a Wacom Cintiq 13HD drawing tablet. I scanned my paintings using a CANON CanoScan 9000F Mark II.

作畫方式 How To

1

繪製這些店鋪插圖的第一個步驟，一定是先參考我們在東京取景時從不同角度拍攝的數張照片，完成草稿。
我刻意選用小素描本或小開數的紙張完成這些初稿，如此才能強迫自己畫得簡單扼要。如果完成度太高、細節太多，就會很難擦除、修正畫作。

The first step to painting one of the storefronts illustrations was always to make a rough sketch based on the photos of the shops taken from various angles during the location hunting we did in Tokyo.
For those first sketches I intentionally used a small piece of paper or a small sketchbook to force myself to keep the drawing simple. It gets harder to completely erase and fix a drawing when it is already all nice and detailed.

2

完成鉛筆線稿、確認整體平衡度沒有問題後，我會使用藍色色鉛筆加上粗略的陰影。到某些店家取景時正在下雨，所以我必須在動筆畫水彩之前，先用這個方式想好晴天下的陰影草稿。

After the pencil sketch is done and there are no issues with the overall balance, I add some rough shadows using a blue colored pencil. Location hunting for some of the shops was done while it was raining, so I had to figure out the shadows sketching like this before painting with watercolors.

3

接下來的步驟，就是在水彩紙上描摹這張粗略的草稿。我會畫出方格，測量圖畫的長寬。

The next step was to get this rough sketch ready to be transferred onto the watercolor paper. I draw a grid and measure the width and height of the picture.

4 正式畫鉛筆線稿和上色之前，我會先用日東電工
（NITTO）紙膠帶把紙張貼在薄木板上，如此描
繪起來較容易，而且畫上水彩後紙張較不容易起
皺變形。

While drawing and painting watercolor, I tape the
paper down to a thin wooden board with the NITTO
masking tape so it is easier to handle and does not
bend nor warp after applying the watercolors.

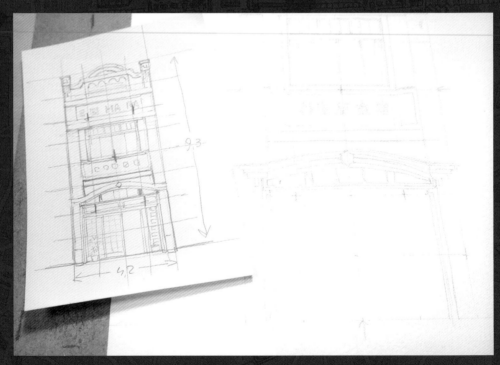

5 只要對照畫好的素描初稿和方格，我就能知道該
如何在較大張的水彩紙上配置店鋪的位置和元素。
我會仔細地描繪店鋪，依照取景時拍攝的照片加
上必要的細節。

By following the small rough sketch and the grid, I
know what elements of the shop should be drawn
where on the bigger watercolor paper sheet. I
sketch the shop carefully, adding necessary details
as I go based on the location hunting photos.

6

這類插圖需要大量細節，才會顯得生動有趣，但是我也要留意避免加入過多細節以維持畫面平衡。

Illustrations like this require a relatively high number of details to be interesting and realistic, but I have to be careful not to put too much in.

7 完成鉛筆底稿後，我用洛登 Isograph 0.50mm 針筆和洛登墨水，為所有的線條上墨。我想盡量讓線條保持寫意感，因此不使用直尺，而且我喜歡徒手畫圖的手繪有機感。如果我注意到某些地方的線條太直了，我會刻意畫得有一點點彎曲。

After the pencil underdrawing is complete, I trace all the lines with ink using the Rotring Isograph 0.5 and Rotring Ink. I try to keep the lines loose – I don't use a ruler – I like the hand-drawn, organic feel a freehand drawing gives me. In some places, when I notice that my lines are too straight, I make them a little wavy on purpose.

8 我也會在各處線條之間留下些許空隙，並且盡量讓所有的線條粗細相同，同一條線我只會描一次。有些非立體的細節（像是招牌上的字樣或牆面磁磚）我不會上墨線，而是稍後直接以水彩繪製。

I also add small gaps in the lines here and there and try to keep all the lines the same thickness – I don't draw the same line more than once.
For some details that are not three dimensional (like letters on signs or wall tiles) I do not ink the lines and paint them directly with watercolors later.

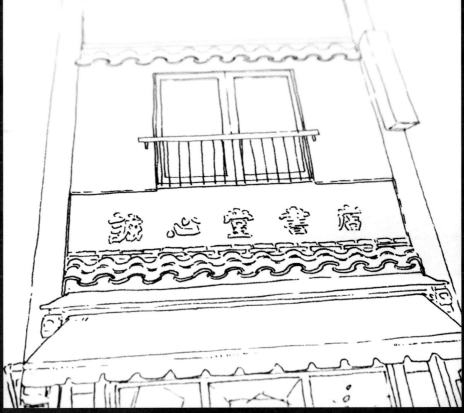

9 完成必要的墨線、確認滿意後，我就會擦去全部的鉛筆底稿。此步驟我使用 MONO 橡皮擦，同時我也會再次確認是否有殘留的鉛筆線。

When I'm satisfied with the ink lines I erase all the underdrawing pencil lines. I use the MONO eraser for this and I double-check if there are any pencil lines left.

10 最後也是最重要的步驟，就是用水彩為畫面上色。不過在上色之前，我會先在畫面中想要保留白色（紙張的顏色）但是周圍不好畫的部分塗上留白膠，像是白色文字或亮點。

The last and the most important step is to color the picture with watercolors. Before I start painting, however, I put on the masking fluid on the parts of the picture that I want to keep white (the color of the paper) that are hard to paint around, like white letters or highlights.

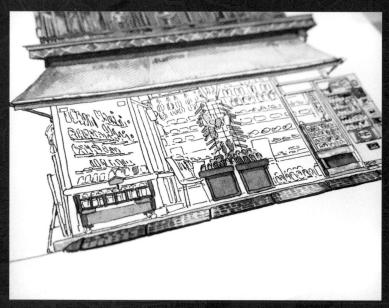

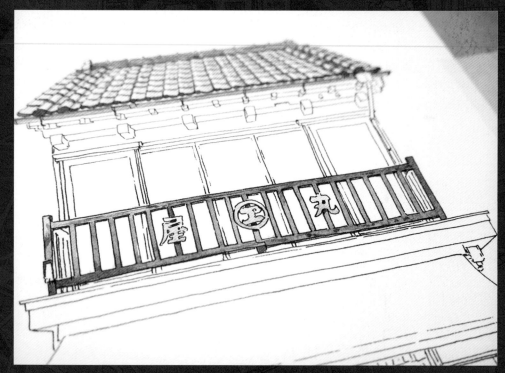

11 上色時，我一定會從淺色慢慢畫到深色部分。這個順序能讓畫面中許多地方更容易描繪，避免深色不小心混入相鄰的淺色顏料。

I always start painting with light colors and the move to the darker parts gradually. This order makes it easier to paint the various parts of the picture without the dark colors mixing into the lighter ones accidentally in the places they touch.

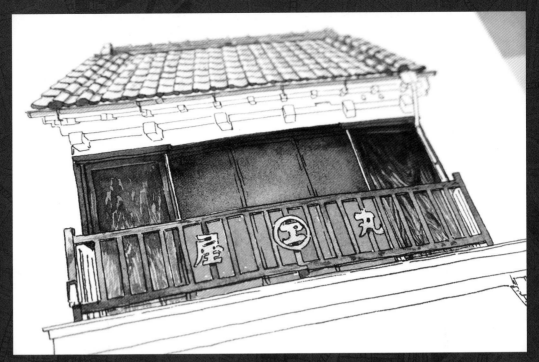

12 最後，我會視畫面需要，在顏料上添加些許紋理和飽經風霜的細節。我傾向讓畫面保持單純，除非必要否則不會疊色。絕大多數的上色處只會畫一遍。描繪花紋和磁磚這類事物時，我喜歡在一大片磁磚上稍稍變化色彩，讓整體顯得更自然真實。

Lastly, I add some textures and weathering details on top of the washes if they are needed. I tend to keep things simple and do not layer paint if it is not absolutely necessary. Most washes I do in one pass. When painting things like patterns and tiles, I like to vary the colors on consecutive tiles a little so the whole pattern becomes more natural and realistic.

13

大部分時候，我最後才會處理字體元素和商標部分的上色。此外，如果在細節和文字上使用留白膠，也是這時候才會擦去。

Most of the time, the last parts I paint are the typographical elements and logos. Also, I rub off any masking fluid if I used it to mask out white details and letters.

後記

除了繪製這本書的插圖，在動筆之前到每一家店取景、和店主聊天談話，更加了解每一家店過去的故事，整個過程充滿樂趣。

我為這個計畫選擇的店鋪絕大多數都頗有歷史（大部分建於二戰後，1926～1989年的昭和時期），但是這些建築的年紀並不是決定我選擇的主要因素。

有些店鋪成為東京相當有名氣的懷舊景點，有些則默默無名，對一般東京人而言，這些店鋪僅是日常都會背景的一隅。我猜想，生長並來自不同文化，同時又是藝術家的身份，賦予我截然不同的新鮮觀點，因此較容易注意到這些事物吧。

製作這本書的用意之一，就是為了點出這些店鋪（以及其他類似的店家）的可看之處，讓它們被注意到，進而被珍視。我在2016年最初畫下的十家店鋪，其中有三家已經不復存在，有的歇業，有的則被拆除。此外，當我們為這本書訪問店主時，得知有些店家即將歇業，有些建築物也即將消失。出版這本書的同時，我也希望更多這類寶貴的店鋪能夠被保存下來。

最後，這只是一本插畫集。我並非日本建築專家，也絕無冒充專家之意。我單純地想在這本書中以水彩插畫的形式，收錄我認為替東京的大街小巷增添色彩與獨特魅力的店鋪。我篡改或美化了某些小地方，不過我希望諸位讀者能夠原諒藝術家的些許自由揮灑。

希望你在閱讀過程中很享受這本書。現在，既然你讀完了，那就快動身前往探索這些店鋪吧！

Afterword

I had tremendous fun doing the illustrations for this book and, before that, location hunting at all the shops, talking to the owners and learning more about the shop's past.

Most of the shops I chose for this project are quite old (most were built after the WWII in the Showa Era from 1926 to 1989) but the age of the buildings was not a deciding factor as to which ones to feature.

While some of the stores turned out to be quite well known as retro spots in Tokyo, some are not recognized at all, and for the usual Tokyoite, they are just a piece of the everyday city background. I guess that being an outsider from a different culture and upbringing and an artist gives me a different, fresh point of view from which it is easier for to notice such things.

One of the purposes of this book was pointing out those shops (and ones like them) so they could be noticed and appreciated.
Three of the ten stores I first painted in 2016 are already gone - closed or demolished. What's more, when we interviewed the shop owners for this book, we learned that some would be closing their stores soon and some of the featured buildings will also disappear. It is my hope that, in publishing this book, more of these precious shops can be preserved.

Lastly, this is just an album of illustrations. I am not an expert on Japanese architecture, nor do I pretend to be one. I simply wanted to put in this book, as watercolor illustrations some of the stores of Tokyo that I think bring the color and unique character to its streets. I have made some changes and embellishments here and there but I hope you will forgive the artist for taking some liberties.

I hope you enjoyed the book and now, that you finished it, go and explore.

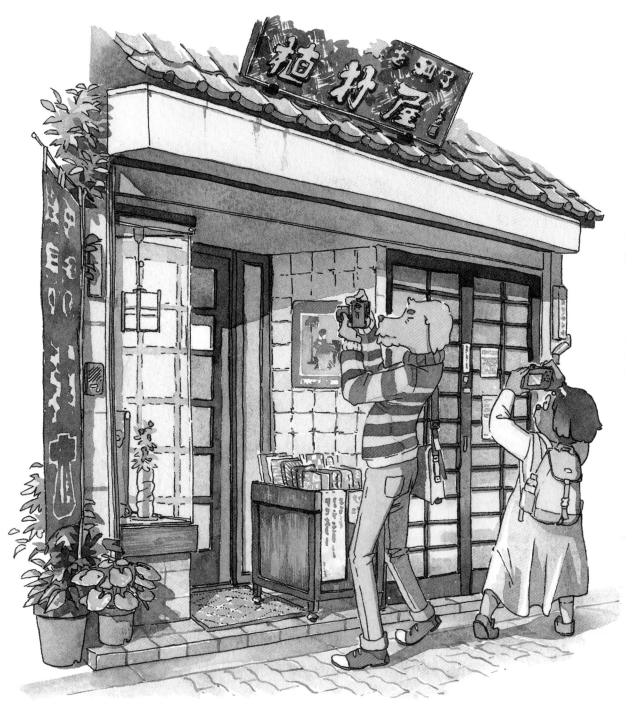

東京・月島植村屋前 / Mateusz 和妻子香苗取景的樣子
Uemura-ya in Tsukishima, Tokyo / Matt and Kana, his wife

給讀者的話

本書不僅收錄仍營業中的店家，也有部分店鋪已拆除、遷址，或是轉為私人住宅。基於這個原因，請各位讀者自制，親臨這些地點時，未經許可請勿擅自闖入或拍攝照片。遵守規則，享受愉快的《東京老鋪》巡禮吧！

—

To the reader

This book contains not only shops that are still in business, but shops that have already been torn down, shops that have moved, and shops that have been turned into private residences. For this reason, we ask that you refrain from trespassing or taking photographs without permission when actually visiting these sites. Follow the rules and enjoy your tour of the delightful storefronts of Tokyo!

協力本書製作的機構與企業團體（依店鋪刊載順序排列 / 敬稱略）

公益財團法人町未來千代田（公益財団法人まちみらい千代田）、佐藤製藥株式會社（佐藤製薬株式会社）、月桂冠株式會社（月桂冠株式会社）、麒麟株式會社（キリン株式会社）

**Organizations and companies that cooperated in the production of the book
(in order of shop appearance, excludes honorifics)**

Machimirai Chiyoda, SATO PHARMACEUTICAL CO.,LTD.,
Gekkeikan Sake Co., Ltd., Kirin Company, Limited

VE0089

東京老鋪

Mateusz Urbanowicz 手繪作品集·中英對照版

原 書 名	東京店構え マテウシュ・ウルバノヴィチ作品集
作 者	Mateusz Urbanowicz
譯 者	韓書妍

總 編 輯	王秀婷
責 任 編 輯	張成慧
版 權	徐昉驊
行 銷 業 務	黃明雪

發 行 人	涂玉雲	
出 版	積木文化	
	104台北市民生東路二段141號5樓	
	電話：(02) 2500-7696	傳真：(02) 2500-1953
	官方部落格：www.cubepress.com.tw	
	讀者服務信箱：service_cube@hmg.com.tw	
發 行	英屬蓋曼群島商家庭傳媒股份有限公司城邦分公司	
	台北市民生東路二段141號11樓	
	讀者服務專線：(02) 25007718-9	
	24小時傳真專線：(02) 25001990-1	
	服務時間：週一至週五09:30-12:00、13:30-17:00	
	郵撥：19863813	戶名：書蟲股份有限公司
	網站：城邦讀書花園	網址：www.cite.com.tw
香港發行所	城邦（香港）出版集團有限公司	
	香港灣仔駱克道193號東超商業中心1樓	
	電話：+852-25086231	傳真：+852-25789337
	電子信箱：hkcite@biznetvigator.com	
馬新發行所	城邦（馬新）出版集團Cite (M) Sdn Bhd	
	41, Jalan Radin Anum, Bandar Baru Sri Petaling,	
	57000 Kuala Lumpur, Malaysia.	
	電話：(603) 90578822	傳真：(603) 90576622
	電子信箱：cite@cite.com.my	

美術設計	張倚禎
製版印刷	上晴彩色印刷製版有限公司／東海印刷事業股份有限公司

Tokyo Misegamae Mateusz Urbanowicz Sakuhinshu
Copyright©2018 Mateusz Urbanowicz
Chinese translation rights in complex characters arranged with MdN Corporation, Tokyo
through Japan UNI Agency, Inc., Tokyo

2019年8月6日 初版一刷
2022年8月22日 初版七刷
售價 650元
ISBN 978-986-459-194-7

城邦讀書花園
www.cite.com.tw

Printed in Taiwan.
版權所有‧翻印必究

國家圖書館出版品預行編目(CIP)資料

東京老鋪:Mateusz Urbanowicz手繪作品集/
Mateusz Urbanowicz 著；韓書妍譯. -- 初版.
-- 臺北市：積木文化出版：家庭傳媒城邦分
公司發行, 2019.08
160面; 18.2 x 24.7公分
譯自:東京店構え マテウシュ・ウルバノヴィ
チ作品集
ISBN 978-986-459-194-7(平裝)

1.建築藝術 2.日本東京都
923.31 108011173

作者

Mateusz Urbanowicz

Mateusz Urbanowicz生於波蘭的西里西亞（Silesia）。在神戶學習動畫，後來在東京的 CoMix Wave Film Studio 工作，擔任動畫背景畫家，參與導演新海誠多部作品（包括〈你的名字〉）。目前是自由創作者，創作漫畫、插畫、動畫及影片，在世界各地擁有許多粉絲。

Born in Silesia, Poland. After studying animation in Kobe started working in Tokyo as an animation background artist in the Comix Wave Films studio, taking part in works of the director Makoto Shinkai ("Your Name."). Currently working as a freelance creator, making comics, illustrations, animations, and videos with many fans around the world.

譯者

韓書妍

法國蒙貝里耶第三大學（Université Paul Valéry）造型藝術系畢。旅居法國九年。目前定居台灣，為專職英法譯者，愛吃愛喝愛貓咪。

日文原書製作人員

編輯／後藤憲司、Sideranch, Inc.
　　　（上原たかし、安齋真代、岡田大輝）
裝幀、內頁設計／齋藤州一（sososo graphics）
編輯協力／ウルバノヴィチ香苗（Kana Urbanowicz）
翻譯協力／ InterBiz, Inc.